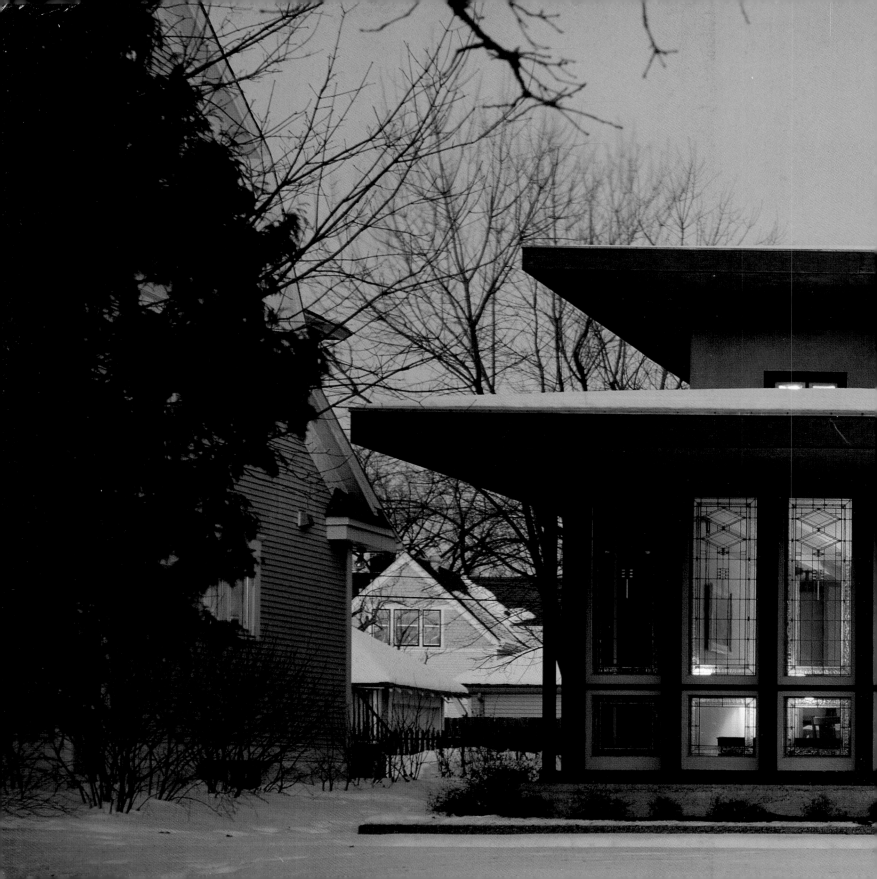

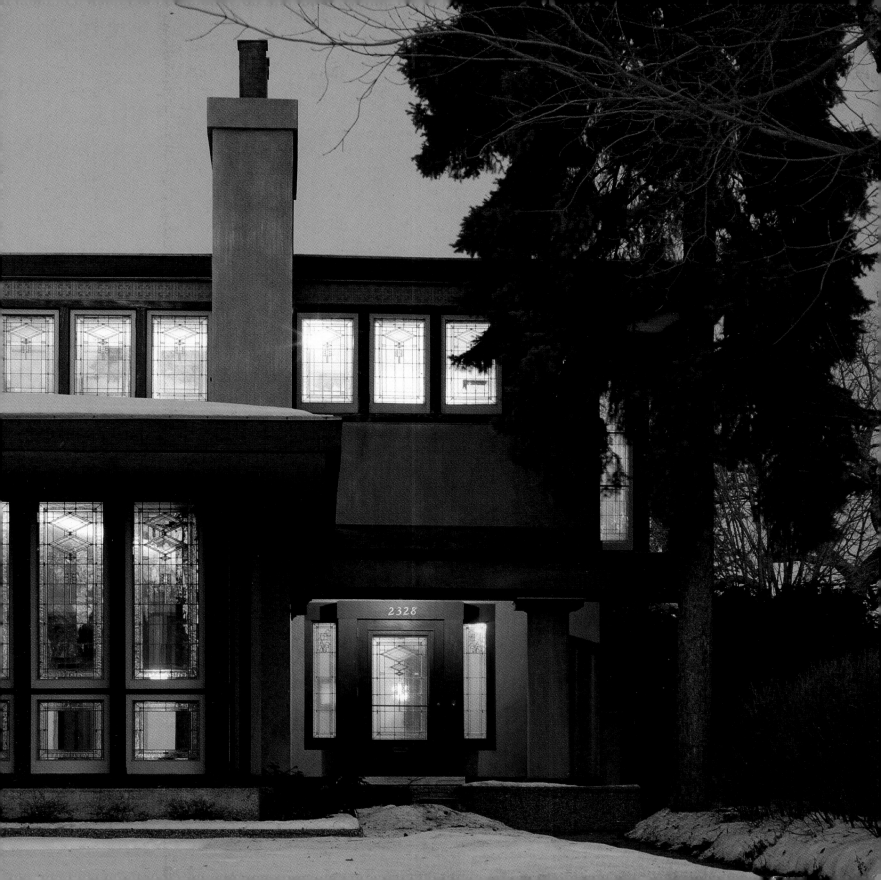

PROGRESSIVE
DESIGN
IN THE MIDWEST

THE **PURCELL-CUTTS HOUSE** AND THE **PRAIRIE SCHOOL COLLECTION** AT THE **MINNEAPOLIS INSTITUTE OF ARTS**

JENNIFER KOMAR OLIVAREZ

with the assistance of CORINE A. WEGENER

Introductory essay by ROGER G. KENNEDY

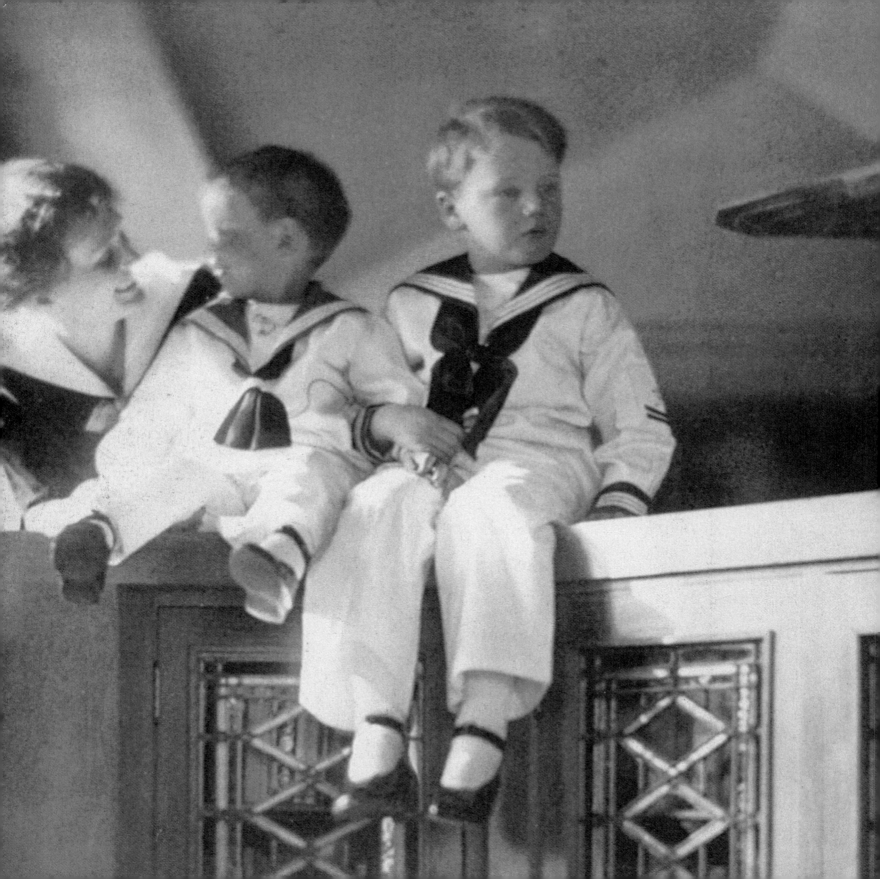

CONTENTS

FOREWORD

The Minneapolis Institute of Arts has had ties to the Prairie School since 1914. In that year Francis Little, who had just moved into a late Prairie School masterpiece by Frank Lloyd Wright on Lake Minnetonka, became a member of the Institute's board of trustees. The Wright connection was reinforced in 1917, when Little gave the museum its first Japanese prints—a magnificent set of Hiroshige's Tokaido Road woodblock prints, which he had obtained from Wright. Other Asian art with a Wright provenance entered the collection in the 1980s, namely Chinese and Korean ceramics acquired through the generosity of another Institute friend, Louis Hill, Jr.

After Francis Little died in 1923, the Minnetonka house continued to shelter members of the Little family for the next fifty years. In 1972, however, this Prairie School home no longer met the family's needs, and it was sold to the Metropolitan Museum of Art in New York with the understanding that it would be dismantled. The Metropolitan retained the magnificent music room for reinstallation in its American Wing, while selling other parts of the building to museums and collectors. The Minneapolis Institute of Arts purchased the corridor leading to the master bedroom, with money from the David Draper Dayton Fund. Although acquired in 1972, the corridor was not on view—except for temporary installations in 1982 and 1994—until the establishment of the Institute's Prairie School gallery in 1998.

More Prairie School objects entered the collection in 1979 with the gift of six ceramic place settings originally designed by Wright about 1922 for his Imperial Hotel in Tokyo. They were donated by Roger Kennedy, a St. Paul native, who wrote the introductory essay for this book. In his role as an architectural historian, Kennedy has done much to broaden the public's appreciation of American architecture in general, and the Prairie School in particular,

through his writings, lectures, and radio and television broadcasts. Kennedy had the good fortune to meet William Gray Purcell shortly before Purcell died and to obtain first-hand accounts of this Prairie School architect's career, along with access to available objects, which Kennedy donated to the Institute in 1998.

Another architectural historian, David Gebhard, had worked closely with Purcell since the early 1950s, while writing his dissertation at the University of Minnesota on the firm of Purcell and Elmslie. Gebhard served as a consultant for the pioneering exhibition on Purcell and Elmslie held at Walker Art Center in 1953. Through the combined efforts of Kennedy and Gebhard and, later, the work of Mark Hammons in the Institute's landmark exhibition *Minnesota 1900*, William Gray Purcell has taken his place next to Frank Lloyd Wright as one of the principal architects of the Prairie School. In 1998 the Institute acquired, by gift and purchase, several Purcell and Elmslie objects collected by David and Patricia Gebhard, which are an important part of this rich history.

Happy to see that Purcell was receiving well-deserved recognition, the last owner of Purcell's own house in Minneapolis, Anson Cutts, Jr., decided the house the architect had designed for himself should be permanently open to the public. In 1985 Cutts willed 2328 Lake Place to The Minneapolis Institute of Arts. The Institute then undertook a major restoration, overseen by Michael Conforti, head of the decorative arts department at the time, and the architectural firm of MacDonald and Mack. The funds Cutts left for the restoration were supplemented by generous donations from Kenneth and Judy Dayton, the Decorative Arts Council, Gabberts Furniture and Design Studio, and the Friends of the Institute, all of whom continue to be vital partners with the Institute on projects concerning architecture and design. The Purcell-Cutts house opened to the public in 1990. With the publication of this catalogue and guide, The Minneapolis Institute of Arts celebrates a decade of having the house on view to visitors from around the world.

The Purcell-Cutts house is without doubt the crown jewel of the museum's Prairie School collection. However, only with the establishment of a gallery devoted to the Prairie School has it been possible to give the house all the attention it deserves. Thanks to a gift of funds from Kenneth and Judy Dayton in 1996, the Institute was able to commission David Swanson of Construct Studios in Minneapolis to make a detailed scale model of the house, which now serves as a focal point of the gallery along with a model of the Francis Little house. A virtual tour of the Purcell-Cutts house, created by the museum's interactive media department, can be viewed in the adjacent gallery.

The Prairie School gallery's northern prospect provides a magnificent view of the Minneapolis skyline, which continues to be a work in progress. Dayton's and Target are key contributors to the vitality of business and architecture in Minneapolis, and the company has been a major philanthropic force in this community and region for over fifty years. Now, thanks to the very generous support of the Target Foundation (formerly the Dayton Hudson Foundation) and the substantial support of Target Corporation Chairman and CEO Bob Ulrich, the Institute has been able to continue its commitment to architecture and design through our permanent collection galleries and the extensive educational public programming that makes works of art accessible to our growing audience.

EVAN M. MAURER
DIRECTOR AND PRESIDENT
THE MINNEAPOLIS INSTITUTE OF ARTS

CHRISTOPHER MONKHOUSE
JAMES FORD BELL CURATOR
DECORATIVE ARTS, SCULPTURE, AND ARCHITECTURE
THE MINNEAPOLIS INSTITUTE OF ARTS

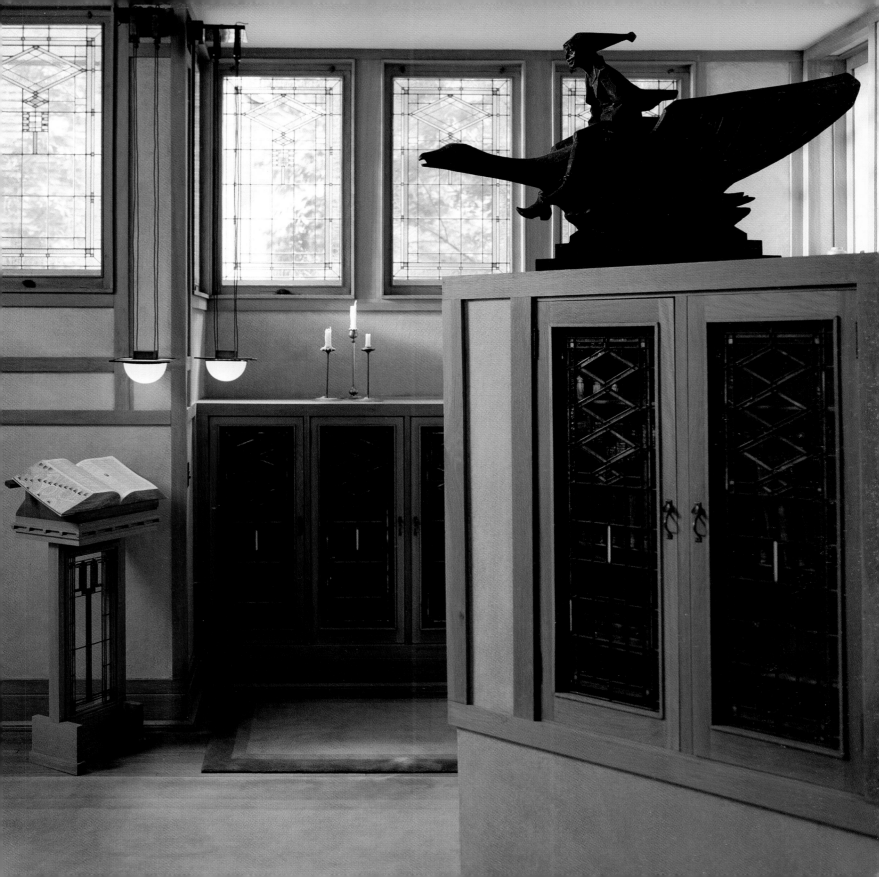

ON BEING A PROGRESSIVE CLIENT

ROGER G. KENNEDY

William Gray Purcell was born one hundred and twenty years ago and entered the penumbra of genius in 1903, at the age of twenty-three, when he was hired as a junior draftsman by Louis Sullivan. I thought Purcell had died in 1917, and in 1964 said so in an elegiac farewell in a television program. Toward the end of that year, a letter arrived, bearing as its signature only a sketch of an old man's smiling face, addressed to "Dear Friend of Good Will," and beginning "I am grateful to you for your favorable opinion of us." By "us" it turned out he did not so much mean himself and Sullivan (by then becoming recognized as the master he was), but himself and George Elmslie, who had been Sullivan's partner before becoming Purcell's.

In a subsequent letter, Purcell invited me to come to Pasadena, where he still lived despite his doctors' prediction of imminent expiration fifty years earlier. I went to see him, and our friendship began. It was grounded, I think, in his amiable recognition that while I had no talent for architecture, and little for architectural criticism, I might as a writer encourage other midwesterners to show the same boldness and confidence as the clients of Sullivan, Purcell, Elmslie, Frank Lloyd Wright, Walter Burley Griffin and Marion Mahony Griffin, and George Maher. The glory days of progressive architecture and its attendant arts extended from the late 1890s until the First World War. Then a pall fell, and the vigor of the Prairie School was replaced by a country club architecture whose derivative excrescences, at once timorous in aspiration and grandiose in scale, still rise each year, in a betrayal of the prairie's subtle contours.

Purcell took up Sullivan's cry that great artists need great audiences and that when great architecture appears it is a sure sign there are great clients about. Purcell's reason for taking time with me was his hope that the profession might be encouraged by a new generation of

educated and confident clients who would revivify the traditions he and the others revered: a careful attention to terrain and to ecological consequences, as well as an intelligent application of technological advances.

Purcell's fundamental lesson was that good architecture comes from a mutually respectful relationship between well-trained professionals and well-trained patrons. He could not then have anticipated the further deterioration of public approbation for professionalism of all sorts—in architecture, in art, in the humanities, and in the science of government. This affliction is made the more malignant by media figures and politicians who curry favor with the lazy and ignorant by assuring them that no exertion is required to bring talent toward competence, and that people who submit themselves to rigorous training are dangerous to a smug uniformity of incompetence.

Purcell's fury at this sort of pandering did not blight his essentially hopeful spirit, for he thought too highly of ordinary citizens to think them beyond igniting once again. Nor did his admiration for the genius of some of his own contemporaries, such as Wright and Sullivan, lead him to see a chasm between the artist and the client. The architect, he taught, had one task, the client another. But they did not represent different orders of being.

Purcell had very high standards for his profession and equally high standards for his clients. During the brief span before progressive architecture was smothered in normalcy and then in depression, its discipline, skill, and competence were welcomed by an intelligent, bold, and receptive audience capable of affirming the best Purcell and his colleagues could do. Although thereafter the Midwest settled for a derivative neocolonialism that graduated into an equally bland International Style, the people of the region were no less capable of worthy clientage than the generation of 1895 to 1915.

The rediscovery of the virtues of Prairie School art offers the hope that the spirit that animated it—not the style itself—may be rediscovered too. Purcell wanted each age to express

itself in what he called "the creatively electric, the wonderfully personal-and-all-containing Now, for doing things." He did not want Prairie School revivals any more than he wanted Jacobean revivals. But he did want clients to seek out architects who would affirm the place in which they would build, its traditions, and its materials. He called for passionate regional pride to be guided by a sophisticated understanding of the great traditions of building—not by the trendy, derivative styles of Nowhereville.

We must, Purcell said, "do for ourselves, feel for ourselves, love for ourselves." Where we are. Put down the slick magazines, he urged, and look out the window.

Think of...our prairies, fragrant [and] beautiful...vast riverways, our great lakes, and the procession of the seasons moving across the face of them....Think of us as a people born into such [an]...environment, and dream of an architecture arising from the dynamics of a [people]...so nurtured, so blessed....Do we believe in our spiritual resources? Then let us rely upon ourselves, let us not forsake ourselves. Do we believe in the divine creative impulse dwelling within us and working through us? Then let us...believe that beneficence may be worked through us, that genuine power is common to us all....Do we believe in the reality of life? Then let us not deny our presence in...an ordered universe. Do we believe in the romance of Life? Then let us utter a song!

Utter a song? Who, me? Embarrass myself by singing, by affirming myself and the artists who choose to work with me? What would the neighbors think?

Purcell and Elmslie found clients in Red Wing, Winona, St. Paul, Minneapolis, Rhinelander, Le Roy, Adams, Hector, and even smaller places. For Winona and Homer, George Maher designed better buildings than any his clients called forth in the suburbs of Chicago. While Greenwich and Far Hills and Grosse Pointe and

Lake Forest were laying up tepid emulations of second-rate European work, the Griffins were giving central Iowa a succession of masterpieces. What is the lesson of this? Great clients do not all live near big cities. What is required for art to flourish is for people to go to the trouble to learn, to consult their own instincts, to look around them, and to seek out the best talent available. And in some not very large communities where people still do for themselves, feel for themselves, love for themselves, the spirit of William Gray Purcell and the Progressive Era is still present. It lives on wherever clients sing for themselves.

Clients matter. But enthusiasm is not enough. Training helps. One gathers confidence from observing very good work. That takes time, and it is made a great deal surer when accompanied by the instruction of people who have exerted themselves to learn. The most pernicious foolishness of our time is the notion that "genuine power" bubbles into instant competence. Professional skill is acquired arduously by discipline, whether that skill be in mastering a golf swing, in learning the rules of accounting, in managing a paintbrush, or in becoming a client worthy of a good architect.

So, let us respect the people who strove to make themselves competent to create beautiful objects. And let us respect ourselves enough to believe that we have the capacity to become good clients—if we work at it.

William Purcell did not summon me to Pasadena in 1965 to talk about himself and his fellow architects of the Progressive Era. He spent our time together exhorting me to do what I could to increase the number of potential clients for architecture he would never see. I hope I have done so.

Roger Kennedy is a native of St. Paul. He served as vice president, finance, and later as vice president for the arts at the Ford Foundation; as director of the National Museum of American History, Smithsonian Institution; and as director of the National Park Service. He is the author of nine books, the most recent of which are *Rediscovering America* and *Burr, Hamilton, and Jefferson.*

THE PURCELL-CUTTS HOUSE

A Modern Home for the Twentieth and Twenty-first Centuries

JENNIFER KOMAR OLIVAREZ

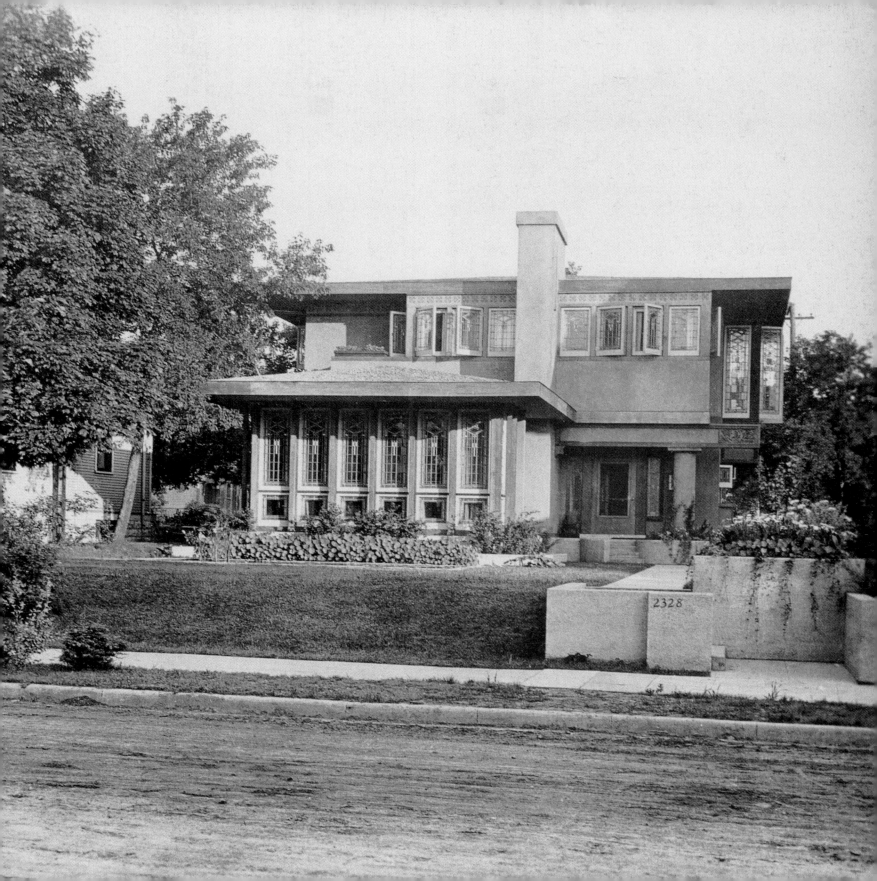

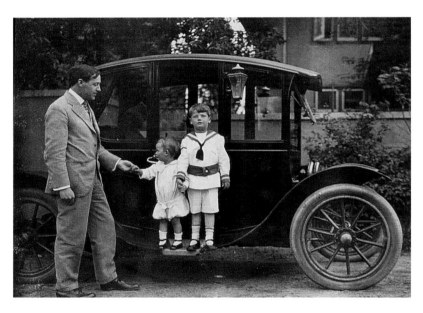

WILLIAM,
DOUGLAS, AND
JAMES PURCELL
IN THE ALLEY
WITH THE CAR,
PROBABLY 1916

One does the beautiful things in this house in a beautiful way because it is easy to do them. —WILLIAM GRAY PURCELL, "OWN HOUSE NOTES"

When the architect William Gray Purcell and his family moved into their new house at 2328 Lake Place in 1913, Minneapolis was a city in transition. Horse-drawn carriages still traversed the dirt roads of the busy downtown residential and commercial areas and the fledgling adjacent neighborhoods, while automobiles and electric streetcars heralded the technologies of the twentieth century. The Purcells built their house south of downtown, within view of Lake of the Isles, by then part of the city's park system. In the 1880s, the newly formed Minneapolis Park Board had acquired the land surrounding the

city's picturesque chain of lakes and hired the landscape architect H. W. S. Cleveland to develop a plan for a citywide park system. The climax of the Park Board's lake district improvements was celebrated in 1911 with the opening of bridges and boulevards connecting the lakes. From that day forward, Minneapolis citizens would have miles of lakefront to enjoy.[1]

Architecturally, the neighborhoods springing up around Cedar Lake, Lake of the Isles, Lake Calhoun, and Lake Harriet embraced both the old and the new. Farmsteads in these formerly rural areas were being replaced by homes chosen from the eclectic menu in vogue early in the twentieth century. As a result, Mediter-ranean palazzi with red-tiled roofs mingled comfortably with English cottages and baronial castles. Some progressive homeowners, however, preferred the most avant-garde architectural style of the time. The Purcells' modern house was starkly unlike its neighbors, with a buff-colored façade, nearly flat roof, and floor-to-ceiling art-glass windows. About 1915, Purcell celebrated this beloved home in the organized poetic musings he called "Own House Notes." The house, he recalled later, was something of a spectacle at the time and "the neighbors never got wholly used to it."[2]

The Edna S. Purcell house (named for Mrs. Purcell), known today as the Purcell-Cutts house, now belongs to The Minneapolis Institute of Arts and is curated by the Department of Decorative Arts, Sculpture, and Architecture.

PAGE 17

THE EDNA S. PURCELL HOUSE (NOW THE PURCELL-CUTTS HOUSE), 2328 LAKE PLACE, MINNEAPOLIS, VIEW FROM ACROSS THE STREET TAKEN BY WILLIAM PURCELL, 1914

AN ARCHITECTURE
FOR MODERN
AMERICANS

The Purcells' house was built in a style still fairly new and unfamiliar at the time, which later became known as Prairie School. Its origins are found in the work of the Boston-born architect Louis Sullivan (1856–1924), who conceived the idea of an authentic American architecture suited to the needs of people living in the modern age.

Sullivan thought that a building should evolve organically, "germinating" like a seed into a whole plant. Its appearance and plan ought to reflect the place and time in which it was built—not some long-gone historical period—and be sympathetic to its site and natural surroundings. He also felt that every structure needed a consistent, unifying "system of ornament." (In his own case, such decoration was literally organic, abstracted from the leaves and flowers of Midwest prairie plants.) Honest use of forms and materials would produce a building that, like a plant, was more than the sum of its parts, one that would be poetic, even enlightening. Sullivan's theories materialized in celebrated commercial structures like the Auditorium Building in Chicago (1887–89), the Chicago Stock Exchange (1893, razed 1972), and the National Farmers' Bank of Owatonna, Minnesota (1907–8).[3]

Sullivan contended that any building could be an honest work of art if organic principles were applied, rather than deceptive "foreign" period styles. Sullivan and his followers championed this home-grown design as a democratic architecture that would improve the lives of all Americans. Sullivan's talented apprentices, Frank Lloyd Wright (1867–1959) and George Grant Elmslie (1869–1952), succeeded in applying organic principles to all building types, particularly house design.[4]

The architects of this younger generation, which also included William Gray Purcell and George Washington Maher, concentrated on the relationship of buildings to their sites and on the concept of unified design. During the years 1895 to 1918, they meticulously applied Sullivan's "system of ornament" throughout their buildings—in art-glass windows, custom furnishings, and integrated artwork. To create visual and functional integrity, they conceived all aspects together. Their sensitive use of natural motifs and colors showed a love and respect for nature fostered by their reading of the nineteenth-century transcendentalists Henry David Thoreau and Ralph Waldo Emerson and the poetry of Walt Whitman. These young men and women also supported the liberal politics and technological advances of their day.[5] They did not, however, have a name for their new architectural style. Wright used the term "prairie school" in 1936, chiefly to describe his work between 1893 and 1910. It then was adopted by later scholars to distinguish the work of Sullivan's followers from that of Sullivan himself.[6]

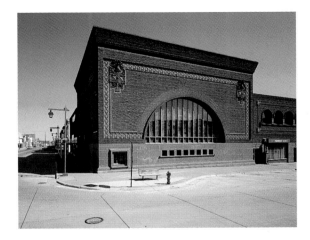

NATIONAL FARMERS' BANK (NOW NORWEST BANK OWATONNA), OWATONNA, MINNESOTA

PURCELL AND ELMSLIE'S ORGANIC ARCHITECTURE

The principles and inherent honesty of organic architecture appealed to William Gray Purcell (1880–1965). The young architect had been born in the Chicago suburb of Wilmette and lived in Oak Park during his childhood. In 1893, his father employed the architect Charles Miller to design a house on Forest Avenue in Oak Park, just down the street from the home Frank Lloyd Wright had built for himself and his family in 1889.[7]

Purcell's father, Charles A. Purcell (1856–1931), was an important member of the Chicago Board of Trade. His mother, Anna Catherine Gray Purcell (1865–1914), was the daughter of Dr. William Cunningham Gray (1830–1901) and the musically and artistically gifted Catherine Garns Gray (1838–1934).

Dr. Gray, a social reformer and prominent literary figure of the time, was the publisher and editor of *The Interior*, a progressive Presbyterian weekly. Purcell spent his early years in Oak Park largely with Dr. and Mrs. Gray.

Each summer Purcell traveled with his grandparents to Island Lake, an isolated retreat in the woods of northern Wisconsin. There Dr. Gray had established a compound of log cabins to recapture some of his own childhood in Ohio. The relationship of human beings to nature was a subject that he emphasized in his column "Campfire Musings," written for *The Interior* in the 1880s and 1890s.[8] Purcell's experience of this virtually unspoiled wilderness and his acquaintance with the Ojibwe Indians there, along with his later reading of romantic poets and novelists such as Henry Wadsworth Longfellow and Sir Walter Scott, fostered a pro-

WILLIAM CUNNINGHAM GRAY, 1890s

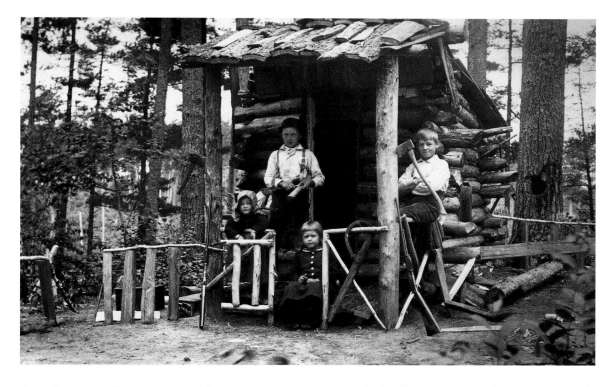

found respect for nature and humanity that carried over to his architectural philosophy. It helped him, he said later, "to value the goodness of plain 'uneducated' people and to accept democratic relations with all men as the normal way of life."[9] It also influenced his design and decoration of homes, particularly the Edna S. Purcell house.

Back in Chicago, Purcell spent his high school years examining the early modern buildings of Sullivan and Wright. This interest was reinforced later when he read the influential texts of John Ruskin and Sullivan while attending architecture school at Cornell University from 1899 to 1903. Their writings, and his own

life experiences, inclined him toward progressive ideas and away from Cornell's classical Beaux Arts curriculum.[10]

In July 1903, Purcell had the good fortune to meet George Grant Elmslie at a social gathering in Chicago. Elmslie was a Scotsman who had come to the United States in 1884. In 1889, Frank Lloyd Wright, who had been working in Sullivan's office, helped Elmslie secure a job there.[11] After Sullivan ended his partnership with Dankmar Adler in 1895, George Elmslie became Sullivan's chief draftsman, a position he held for the next fourteen years.

Purcell's wish to explore progressive design impressed Elmslie, who immediately hired him to work in Sullivan's office. His stint lasted for five months, from August to December 1903. It was then, while Purcell was absorbing the tenets of organic architecture, that his lifelong friendship with Elmslie began. Unfortunately, Sullivan's firm was just finishing the Schlesinger and Meyer (later Carson Pirie Scott) department store

commission, and soon there was little work for Purcell. Early the next year, he departed for the West Coast, where he spent two years working for various architects in San Francisco and Seattle.[12]

In March 1906, Purcell made a grand tour of Europe with George Feick, Jr. (1881–1945), a Cornell classmate who had trained as an engineer. The two young men viewed historical masterworks of art and architecture, and they also met some of Europe's avant-garde architects.[13] Upon their return to the United States in 1907, with financial support from Purcell's father, they opened their own architectural office, Purcell and Feick. They located their firm in Minneapolis, where they saw an opportunity to promote organic architecture in a relatively undeveloped market.

The firm soon included several drafters, artists, and designers, whom Purcell referred to as "the Team." All the employees participated in the design process, and all drafters signed their work. Purcell and Feick made a radical move in 1908 by hiring a woman, Marion Alice Parker

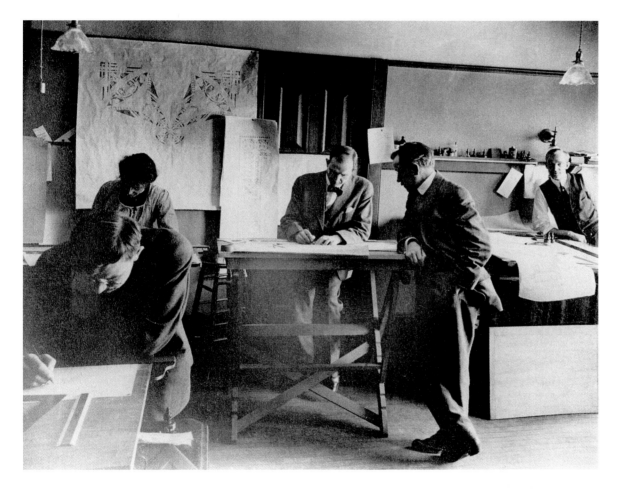

PURCELL, FEICK
AND ELMSLIE
OFFICE, WITH
MARION ALICE
PARKER (LEFT),
GEORGE ELMSLIE
STANDING IN
FRONT OF
DRAFTING TABLE,
AND GEORGE
FEICK, JR. (LEFT
FOREGROUND),
ABOUT 1910

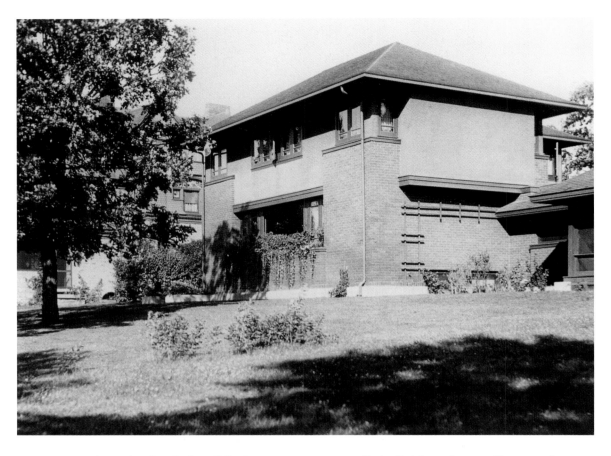

(1875?–1935), as the firm's first full-time, per-manent drafter.[14] By December 1909, Sullivan's fortunes were waning, and he could no longer pay George Elmslie. Early the next year Elmslie joined Purcell and Feick as a partner, and the firm became Purcell, Feick and Elmslie; when Feick left in 1913, the firm continued as Purcell and Elmslie until 1921.[15]

In the years before Purcell built his own home near Lake of the Isles, Purcell and Feick filled two commissions for houses that still stand today, not far from the site where Purcell himself

eventually built. These homes illustrate the progressive qualities that became hallmarks of the firm's work.

The first of Purcell's progressive plans actually built was a home for his grandmother. Purcell's grandfather William Cunningham Gray had died in 1901, and in 1907 Catherine Gray moved to Minneapolis to be closer to her grandson. The house, originally called the William Gray Purcell house, was to be a home for both of them.[16] Early that year, Purcell had made some sketches for it but had difficulty putting his ideas down as plans and elevations.

After one futile attempt, he brought his friend Elmslie into the picture. Purcell sent new sketches to Chicago for Elmslie, asking for his suggestions, and Elmslie replied with his own pencil plan. By July 1907 Purcell had elevations and working drawings, which he took to Chicago to be critiqued by both Elmslie and Wright. Though Wright gave advice that was more prophetic than practical, Elmslie generously worked out the design with Purcell, a collaborative method they would employ throughout their partnership.[17]

Construction of the house, located at 2409 East Lake of the Isles Boulevard (now East Lake of the Isles Parkway), began in August, and Purcell and Catherine Gray moved in at Thanksgiving 1907. Later known as the Catherine Gray house (to distinguish it from the Purcell family's house on Lake Place), it was an important work for the fledgling architectural firm. The rectangular two-story structure was, overall, very

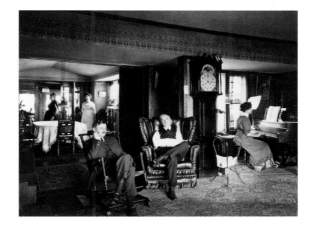

CATHERINE GRAY HOUSE, LIVING ROOM WITH GEORGE FEICK, JR. (LEFT), CHARLES A. PURCELL (CENTER), AND EDNA PURCELL PLAYING THE PIANO, AND DINING ROOM WITH CATHERINE GRAY (LEFT) AND HER COMPANION ANNIE ZIEGLER, ABOUT 1908

similar to Wright's famous design for a "Fireproof House for $5000" published in the April 1907 *Ladies' Home Journal*. Purcell defined and varied the monolithic exterior through the use of brick on the first floor and natural-colored stucco on the second floor. This house marked the firm's first use of casement (rather than sash) windows and an asymmetrical entry, which became standard for them. A partially open floor plan and a system of wood trim throughout the rooms unified the interior. The raised hearth, borrowed from Swedish vernacular architecture, made the fire a focal point, as it had been at the Island Lake camp.[18] Among the alterations to the

Catherine Gray house over the years was the removal in 1918 of a lovely screened pavilion to the south.

On December 29, 1908, Purcell married Edna Summy (1881–1959), a Wellesley graduate with a music degree. Like William, she also came from a well-to-do Chicago family; her father, Clayton F. Summy, owned a music publishing business. Edna moved into the house with William and Catherine, and the couple lived there for a short time. In early 1909, Purcell decided to pursue the construction of furniture specially designed for the house. Working drawings produced April 14, 1909, labeled "Furniture for Own Home," include a tea tray, andirons, a set of three trestle-type tables (to be used together for large dinner parties or separately for intimate ones), high-back chairs for dining, and a low "living room chair." These furnishings—the tables and chairs to be stained metallic green—were an exercise in form, not decoration. All the pieces were rec-

tilinear, and the chairs had cross-shaped back splats.[19] At least the dining room furniture and the living room chair were made and were eventually used in the Edna S. Purcell house, on Lake Place. In August of 1909, Purcell had similar furniture made for the house he designed that year for his father in River Forest, Illinois.[20] Since the interior photos of the Catherine Gray house show only Mrs. Gray's nineteenth-century furniture, it seems likely that William and Edna did not use the custom-made furniture until after they had moved out of the house.

The second pivotal commission near Lake of the Isles was a house for E. L. Powers, a vice president of the Butler Brothers mail merchandising company. It was built at 1635 East 26th Street, not far from the Catherine Gray house. The commission was received in 1910, soon after Elmslie joined the firm, bringing his skill in spatial arrangement and organic design. The

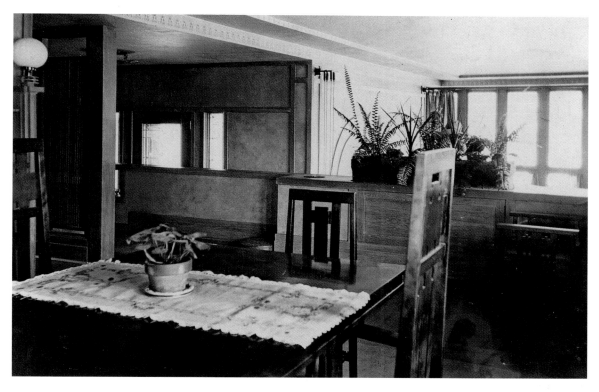

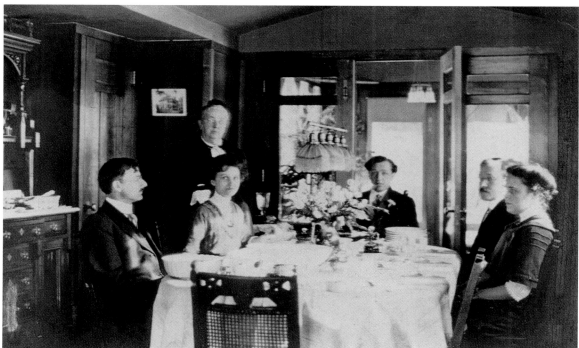

TOP

FURNITURE
DESIGNED FOR THE
CATHERINE GRAY
HOUSE IN USE IN
THE EDNA S.
PURCELL HOUSE,
ABOUT 1914

BOTTOM

FROM LEFT:
GEORGE FEICK, JR.,
EDNA PURCELL,
CATHERINE GRAY
(STANDING),
WILLIAM PURCELL,
GEORGE ELMSLIE,
AND BONNIE
ELMSLIE AT THE
CATHERINE GRAY
HOUSE, ABOUT
1910–11

E. L. POWERS
HOUSE, DINING
ROOM, ABOUT 1910

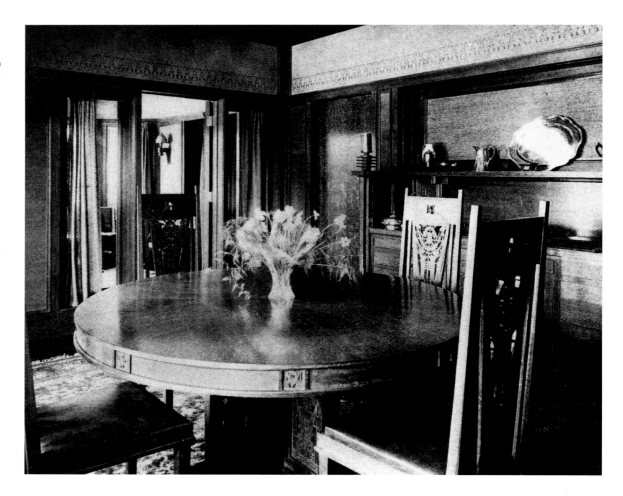

architects radically rearranged the typical house plan to fit the site, situating the living areas in the back, which originally had a view of the lake. Elmslie devoted his talents to devising a system of ornament, matching Sullivan's best efforts and setting a precedent for Purcell's own house. He designed terra-cotta decorations with stylized plant motifs for the entrance and the interior fireplace wall; art-glass panels with geometric plant forms for porch doors and bookcase doors; built-in and freestanding furniture for the dining room, all with organic sawed-wood designs; and custom stencils throughout the house.[21]

Purcell, Feick and Elmslie's work was recognized by local and national publications as the best of new design in its own day. *The Western Architect*, a journal that promoted modern architecture, showcased the firm's work in special issues in 1913 and 1915. And both Purcell and Elmslie wrote on the subject of progressive architecture.[22]

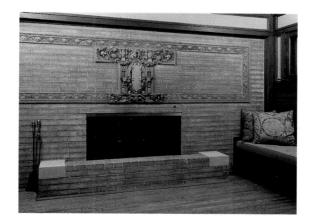

TOP

TERRA-COTTA DECORATION ABOVE THE LIVING ROOM FIREPLACE, E. L. POWERS HOUSE

BOTTOM

PAGE LAYOUTS DESIGNED BY PURCELL AND ELMSLIE, FEATUR- ING THEIR WORK, IN *THE WESTERN ARCHITECT*, JANUARY 1913 (LEFT) AND JULY 1915 (RIGHT)

A HOUSE FOR
THE PURCELLS,
A MODERN FAMILY

Houses should not be clamps to force us to
the same things three hundred and sixty-
fi[v]e days in the year; they should not be
ordering us about regardless of breeze and
sunset, but they should be backgrounds for
expressing ourselves in three hundred and
sixty-five different ways if we are natural
enough to do so.[23]

Around 1911, William and Edna
Purcell began to think about
building their own home. They
had been living in an apartment
on Humboldt Avenue, several blocks from
Catherine Gray, and their thoughts were turning
to a permanent dwelling for their family. That
year, they had adopted the first of their two
children, an infant boy, James (born August 8,

1911).[24] In addition, William was becoming
more active in professional organizations, and
both he and Edna were involved in various arts
and social groups. A house would provide a
showcase for the firm's expertise as well as a focal
point for the Purcells' social life.

In planning his new "own home," to be built
at 2328 Lake Place, just northeast of his grand-
mother's house, Purcell eagerly put to use all he
had learned about organic architecture since his
collaboration with Elmslie on the Catherine
Gray house. He intended to build a truly pro-
gressive home that would nurture a new, "mod-
ern American family life."[25] Purcell was anxious
to prove the obsolescence of the Tudor, baronial,
and other "style period" houses that were begin-
ning to populate his chosen neighborhood. He
considered them to be thoughtlessly designed,
filled with wasted spaces included only because
society seemed to require them, and cluttered

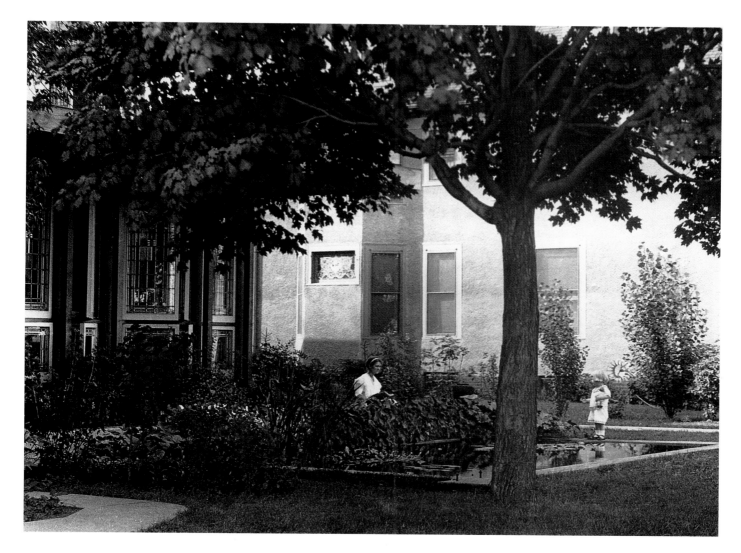

with too many possessions.[26] In retrospect, Purcell viewed the Edna S. Purcell house as "perhaps the most complete dwelling" that he and Elmslie had collaborated on.[27] Thanks to financial help from his father, he could afford to build it. The approximately 3,200-square-foot house cost about fourteen thousand dollars, not an unusual amount for the neighborhood at the time but significantly more than most houses of its size. William, Edna, and James moved into the house at Christmas 1913.[28]

EDNA AND JAMES PURCELL IN THE FRONT GARDEN OF THE EDNA S. PURCELL HOUSE (WITH NEIGHBORING HOUSE TO NORTH), PROBABLY SUMMER 1914

EDNA AND JAMES
PURCELL IN THE
FRONT GARDEN,
EDNA S. PURCELL
HOUSE, PROBABLY
SUMMER 1914

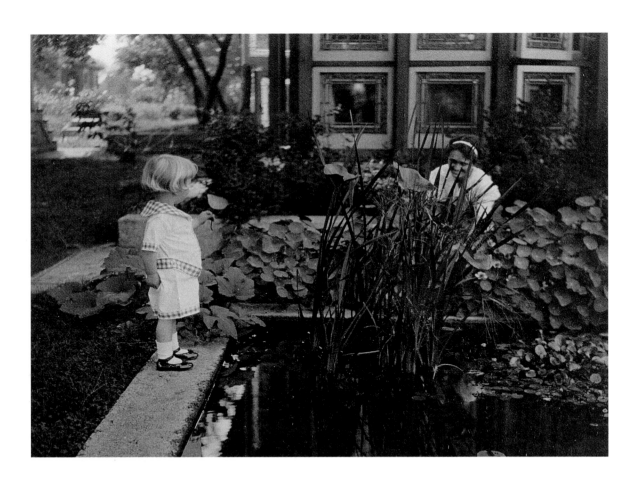

Out of Alignment with Its Neighbors

Dubbed the "Little Joker" by Elmslie, the Purcells' house was to occupy a 50 × 150-foot city lot on Lake Place, a two-block diagonal street between Irving Avenue and Lake of the Isles Boulevard. Long and narrow and fairly flat, the lot had "a view between old houses on broad lawns facing the Park Boulevard."[29]

Purcell took it as a personal challenge to design an imaginative house specifically for this lot. For a start, he set the house back approximately thirty feet from the front property line, well back of its neighbors to the north and south. This allowed for the dining room, with its wall of windows, and the porch in the rear of the house to look out on the neighbors' gardens instead of into their windows. Where the houses were close together, unbroken walls preserved privacy.[30]

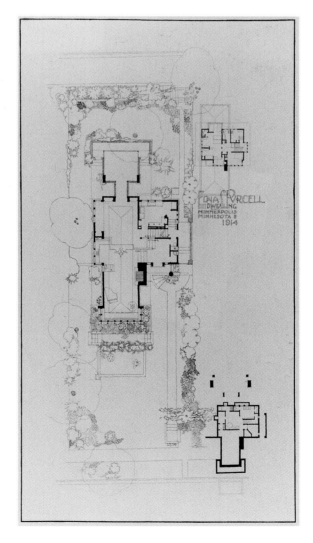

TOP

FRONT (EAST)
VIEW, PROBABLY
SUMMER 1914

BOTTOM

THE WATER
GARDEN WITH
ITS FOUNTAIN,
PROBABLY
SUMMER 1914

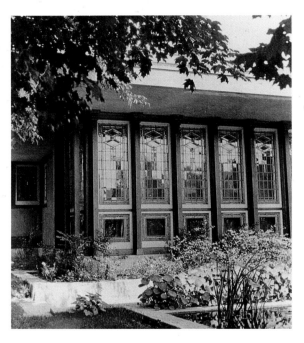

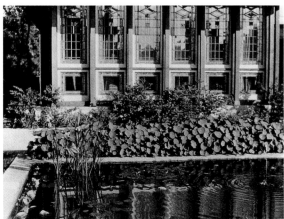

With a lake view to the west and neighbors' gardens to the north and south, Purcell only needed an eastern garden, at the front, to make his house an urban oasis. The landscape architect Harry Franklin Baker worked with him to create a plan in which free and structured elements combined to unite house and site in the typical Prairie School manner. They designed a rectangular concrete reflecting pool containing a small fountain and water plants. Informal plantings and ornamental trees throughout the site complemented the nasturtiums, vinca vines, and water lilies in the numerous rectangular planters and the pool.[31]

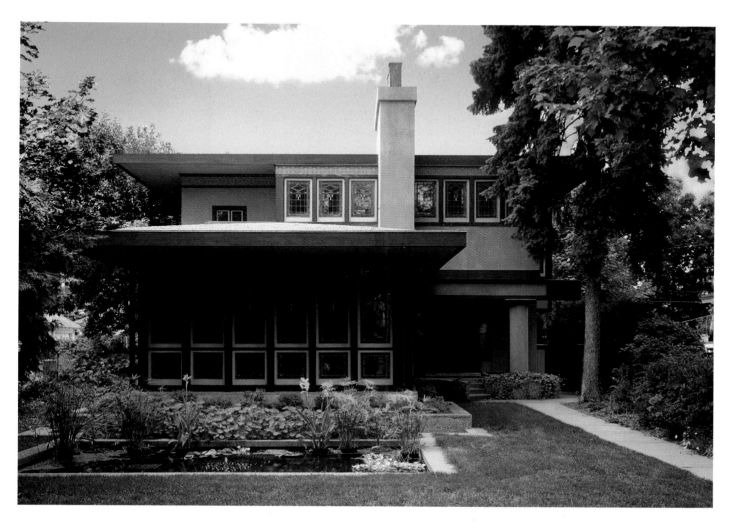

EDNA S. PURCELL
(PURCELL-CUTTS)
HOUSE

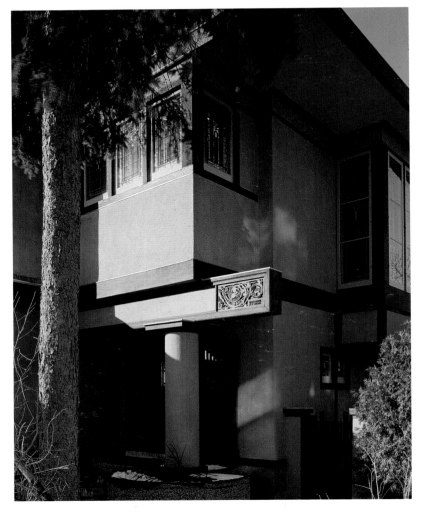

Introduction to a Personalized Home

The Purcells' new house had a steel-reinforced structure and reddish buff-colored stucco exterior. In keeping with its site, the two-story house appeared strongly horizontal, owing to the overhanging eaves, including a seven-foot projection at the front (east) of the house.[32] The eaves also regulated light and heat entering the house, acting as a shield on hot days. A wall of windows under the eaves connected the interior of the house to the garden and reflecting pool. Bands of windows on the second floor, some spanning more than one room, contributed to the horizontal line. And a continuous band of red and blue stencils designed by Elmslie provided an imaginative, low-cost alternative to an expensive terra-cotta frieze.

Purcell and Elmslie's embellishment of the exterior tended toward a strict geometry. The architects included narrow piers of spruce between the mullions of the front windows and put cypress wood trim on the fascia of the upper

and lower floors and around the window frames. Both the piers and the trim were given a "jin-di-sugi" treatment learned from the Minneapolis interior designer John Scott Bradstreet (1845–1914). In this adaptation of a traditional Japanese technique, wood is artificially aged either by burning or by applying chemicals. Here, creosote was used, giving the wood a lovely dark color.[33]

For visual variety and to give the "Little Joker" a personal touch, Elmslie created some special motifs. The beam-end decoration above the side gate, with the motto Gray Days and Gold, refers to Purcell's grandparents, to the colors of the firm's progressive architecture, and to the funds (provided by Purcell's father) supporting the architectural practice and the house. The monogram atop the screen to the right of the front door, an intertwined ESP (for Edna S. Purcell), can also be read as P&E (for Purcell and Elmslie) or as a treble clef (a reference to Edna's love of music).

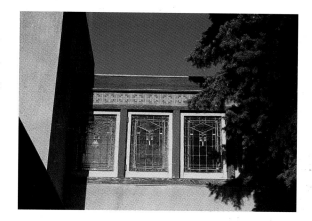

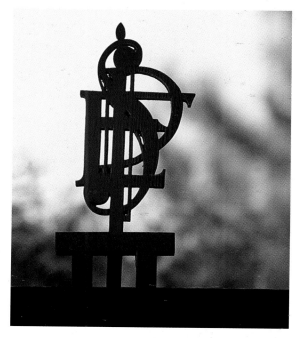

TOP
SECOND-FLOOR
WINDOWS AND
STENCIL

BOTTOM
"ESP" MONOGRAM
ATOP SCREEN AT
THE ENTRANCE

LEFT

PURCELL'S EARLY
SKETCH FOR A PLAN
OF THE EDNA S.
PURCELL HOUSE,
SHOWING THE
DEVELOPMENT OF
THE SUNKEN LIVING
ROOM, EARLY 1913,
WITH PURCELL'S
NOTES TO ELMSLIE:
"Or referring to
basement plan
could we drop
down into the
basement space
with L. R. to get
high ceiling effect
which Edna is
crazy to have.
This would give us
the porch high
with good over
look from rear
towards lake and
towards Grand-
mother and a
more intimate
garden opening
out with great
windows toward
street."

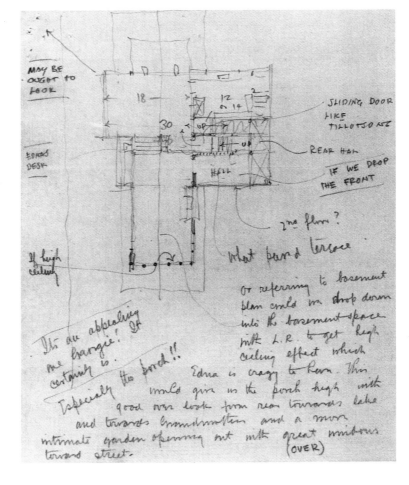

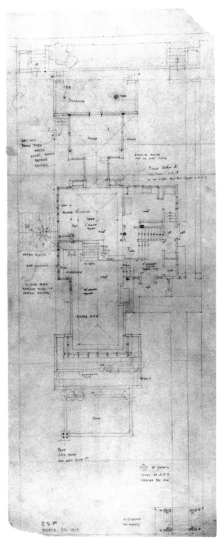

The Evolution
of an Open Plan

One of the progressive characteristics Purcell wanted for his home was an open floor plan. He considered this essential for the new, modern American way of living that he envisioned for his family. The open plan was radically less formal than the interiors in which his parents' generation lived, where the spaces dictated the activity that went on inside them. Wright called it "breaking out of the box." The space that resulted was both physical and psychological. "What we needed to do," Purcell wrote, "was to lose, not so much the parlor as the parlor idea of life—and when that went the resulting change in form bore witness to a very definite occurrence." [34]

Creating an open plan for his own house was Purcell's challenge, and he was aided once again by George Elmslie. [35] The treatment of the main first-floor living spaces was crucial. Purcell knew early on that he wanted his living room and dining room to flow together. He had suggested a continuous tented ceiling to connect the two spaces, which initially were to be on the same level. But Elmslie was not encouraging: "continuous roof, continuous ceiling, continuous interest. BAH." [36] Yet Elmslie, Purcell, and Edna all became attached to the idea, especially after Purcell suggested dropping the living room down into the basement space and elevating the dining room. Numerous early sketches show one central staircase or two side staircases linking the two spaces. In the end, Elmslie placed a single staircase on the side near the front entry, allowing space for the "prow," the V-shaped projection in the center of the main floor.

OPPOSITE, RIGHT ELMSLIE'S SKETCH FOR A PLAN OF THE EDNA S. PURCELL HOUSE, 1913, MORE FULLY DEVELOPED, BUT WITH THE STAIR FROM LIVING ROOM TO DINING ROOM STILL ON THE MAIN FLOOR'S CENTER AXIS

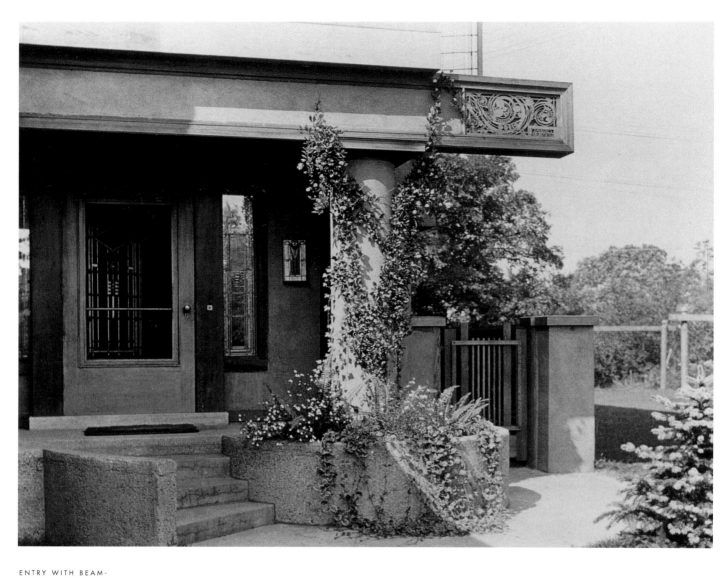

ENTRY WITH BEAM-
END DESIGN,
ABOUT 1914

Living in a
New Type of Space

THE ENTRY AND LIVING ROOM

In this dwelling the useless division between recent sun room and living room quietly slipped away. A new place appeared within the house, all free and open, filled with soft light, tributary in all parts to the hearth; all parts invite one to exercise the various functions of everyday living. One can live all over the single room of the entire lower floor according to the time of day or his mood.[37]

The entry to the house radiates the beauty, welcome, and whimsy Purcell desired. The art-glass front door is flanked by twin windows decorated with the words "Peek a Boo," one to be viewed from the outside, the other from the inside. The entrance hall is connected to the main living areas, giving a generous preview of what is to come.

The visitor is greeted by a large oil portrait of Grandfather Gray at Island Lake, painted in the early 1890s by Lawton Parker. (Dr. Gray had supported Parker's studies at the Art Institute of Chicago and later in Paris, after Parker won a drawing contest in *The Interior*. Parker went on to make a name for himself as an Impressionist painter.) According to family history, this painting was displayed at the World's Columbian Exposition in Chicago. Purcell had inherited it when Grandfather Gray died, and in 1913 he installed it in his house, where it has been ever since.[38] This picture of Grandfather Gray was the first in a series of artworks Purcell planned for the house; those to follow had to fit within the

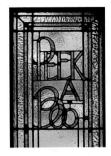

TOP

"PEEK A BOO"
WINDOW DETAIL

BOTTOM

ENTRY VIEWED
FROM THE LIVING
ROOM, WITH
PORTRAIT OF
DR. GRAY

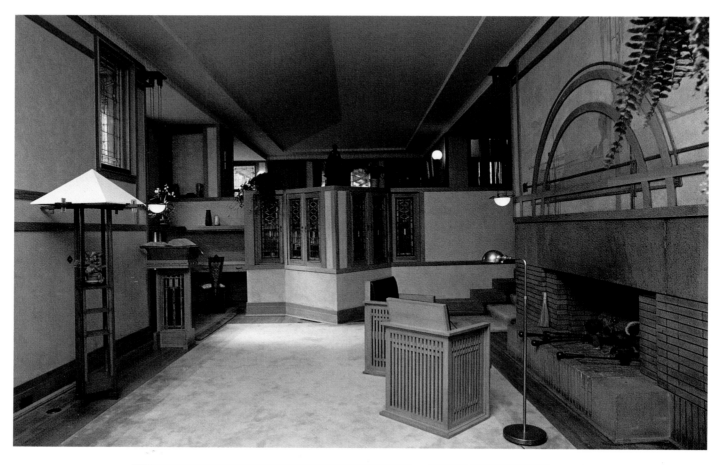

TOP
LIVING ROOM

LEFT
EAST END OF THE
LIVING ROOM,
WITH WINDOW
WALL, ABOUT 1915

RIGHT
EDNA PURCELL BY
THE FIREPLACE
BEFORE THE MURAL
WAS PAINTED, 1914

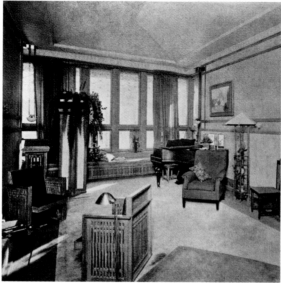

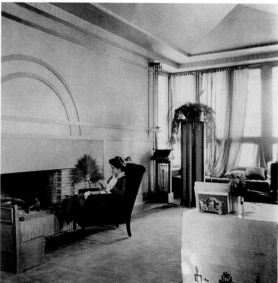

budget of a hundred to a hundred and fifty dollars that he allowed for each one.

The effect produced by a successful unified design is immediately apparent. The walls, echoing the colors of the exterior (originally what Purcell called "rose chamois") have been restored to match the fireplace mural and are now a salmon color. Along the top of the walls, stencils in organic patterns, designed by Elmslie, wrap the perimeter of the living and dining areas—and every other room in the house except the entry. The interior spaces are linked with warm, unstained oak: in the bookcases and hallway screen, the baseboards, and the frieze area below the stencils. The custom rugs (now reproductions) in muted brown and mauve, with dark borders, complement but do not overpower the other decoration. Most striking are Elmslie's geometric designs for the windows. From the outside, the glass patterns, with their diamond shapes descending in size, form a visual barrier; but from the inside, they are a kind of prism through which to view the outdoors. For the more than eighty art-glass panels in the house,

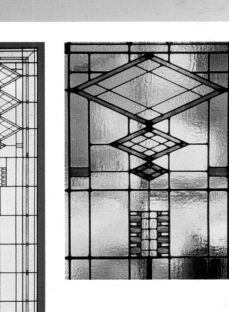

TOP
STENCIL PATTERN IN
THE GUEST ROOM

LEFT
WINDOW DETAIL

RIGHT
FRONT DOOR
DETAIL

45

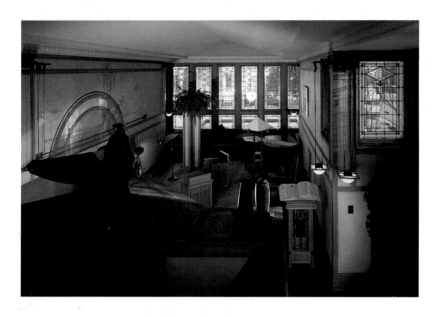

and south corners, so that one feels enveloped by nature, an effect reinforced when the casement windows are opened to outdoor sounds and scents. On summer mornings, reflections from the pool stream across the cantilevered overhang and onto the living room ceiling. In "Own House Notes," Purcell recalled

...one extremely hot August day—sticky and dusty downtown—coming home to some fresh clothes—but still the heat—and then down to tea; and there in the end of the Living Room, all open toward the east with the little pencil stream of the fountain puttering away among the pale yellow water hyacinths, was the evening table so cool looking, with two cool little colored chairs[,] one lilac one. The house had begun to show its desire to say things at the right time. The coolest looking tea table in town, I'm sure—most of them that night sitting in the same surroundings that felt good last winter.[40]

each subtly different from the others, E. L. Sharretts's Mosaic Art Shops charged no more than a reasonable five hundred dollars.[39]

Four steps down from the entry, the strikingly spacious and beautiful living room opens toward the east and south. It is truly a multipurpose space, with three focal points—the east end, the fireplace, and the writing nook—that invite a variety of activities. At the east end, a fourteen-foot window seat runs the width of the room. The window wall wraps around the north

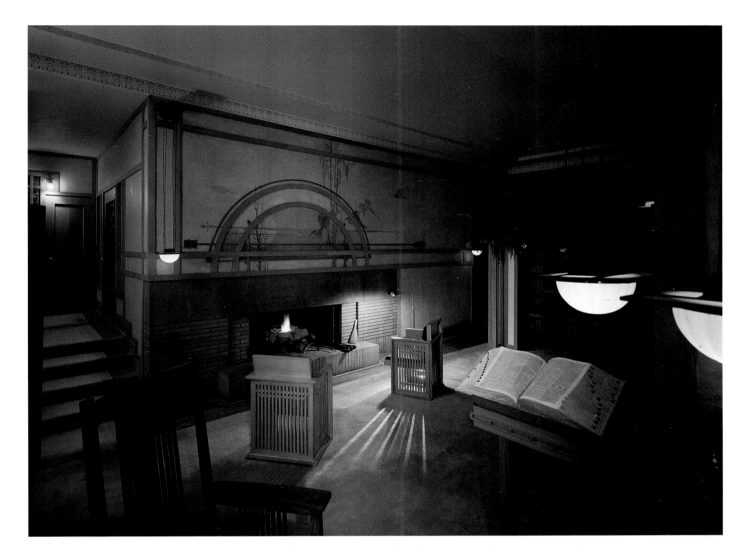

It was in this part of the room that the Purcells placed their custom-finished piano and staged concerts. (The present piano belonged to the home's second owners, the Cutts family.) Nearby hangs Albert Fleury's *Chicago River*, which Purcell purchased from the artist, no doubt to remind him of his hometown.

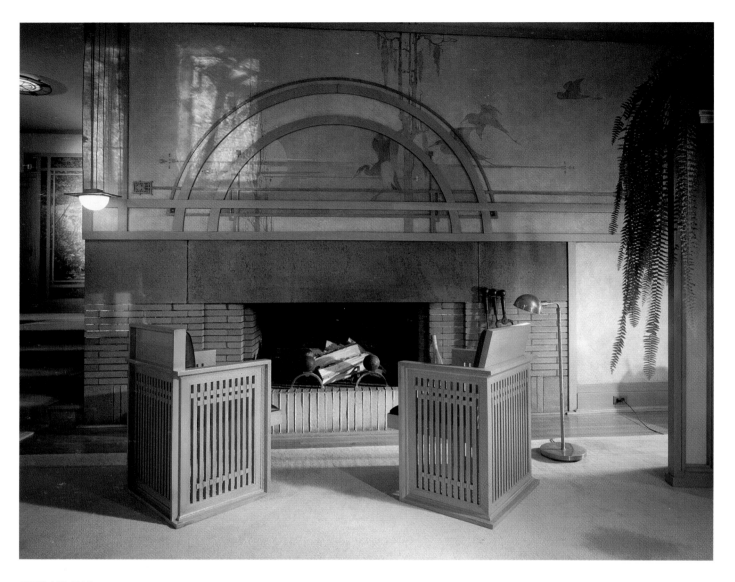

FIREPLACE WALL
WITH MURAL
BY CHARLES
LIVINGSTON BULL

The fireplace had a central, symbolic significance for Purcell that went back to his days by the campfires at Island Lake. This fireplace, like that in the Catherine Gray house, has a raised hearth. It is of roman brick, with iridescent glass, which sparkled in the firelight, embedded in the horizontal mortar joints. There is no mantel here to attract clutter and dilute the artistic effect. Across the top of the fireplace Purcell placed what he called "the last piece of raindrop [sand-stone] in Minnesota," of a variegated purplish color. For the chimney wall above, George Elmslie created the basis of a wall decoration with arched bands of wood.

Purcell wanted a mural above the fireplace, and with Elmslie's assistance he located Charles Livingston Bull, an illustrator of children's books who excelled at painting animals. In November 1914, Bull came to Minneapolis to execute his design of Louisiana herons flying, with two moons. The mural was painted around the two arched bands of wood and further embellished by sawed wood and art glass of Elmslie's design. Bull was so well known that the event was cov-

ered by the Minneapolis *Tribune*, and Purcell was quoted on his desire for a painting that fit his program of unified design: "I wanted a real wall decoration in my living room; one which would preserve the essential character of the wall, that of flatness."[41] Now cleaned, the fireplace mural remains one of the most dramatic features of the house.

Aesthetically and functionally integral to the living room, the Purcells' hearth was enticing at all times of the day.

On fine Minnesota winter mornings when the first level sun rays come slanting over the snowy house tops just at breakfast, the table time and again is laid in front of the Living Room fire. The electric toaster sits on the end of the hearth and the coffee and cheese and jam come down from the kitchen above at their leisure.[42]

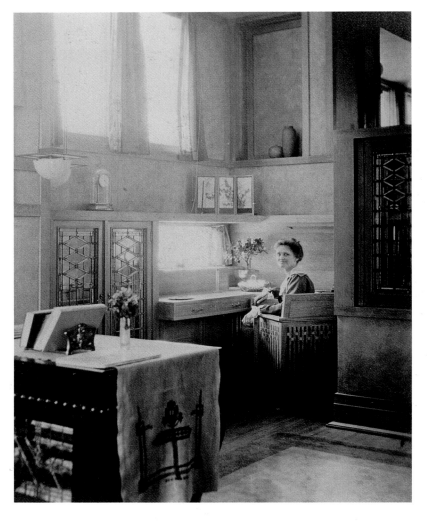

EDNA IN THE
WRITING NOOK,
1914

OPPOSITE
JAMES, DOUGLAS,
EDNA, AND
WILLIAM AT THE
PROW, PROBABLY
LATE 1916

Tucked between the prow and the south wall, the writing nook forms the third and most intimate area of the living room. It was planned as Edna's space, and photographs show her there among her correspondence and personal photos. Like the window seat and the hearth, it is best appreciated when in use. Seated at her desk, Edna looked out the long horizontal ground-level window onto a wildflower garden. The floral pattern in the window (the only flower design in the house) echoes the outdoor scene.[43]

In the matter of furnishings, Purcell wished to carry out the philosophy of unified design with furniture made specifically for his house. He partially achieved this with the built-in window seat, writing-nook desk, and bookcases. Elmslie designed a number of pieces of loose

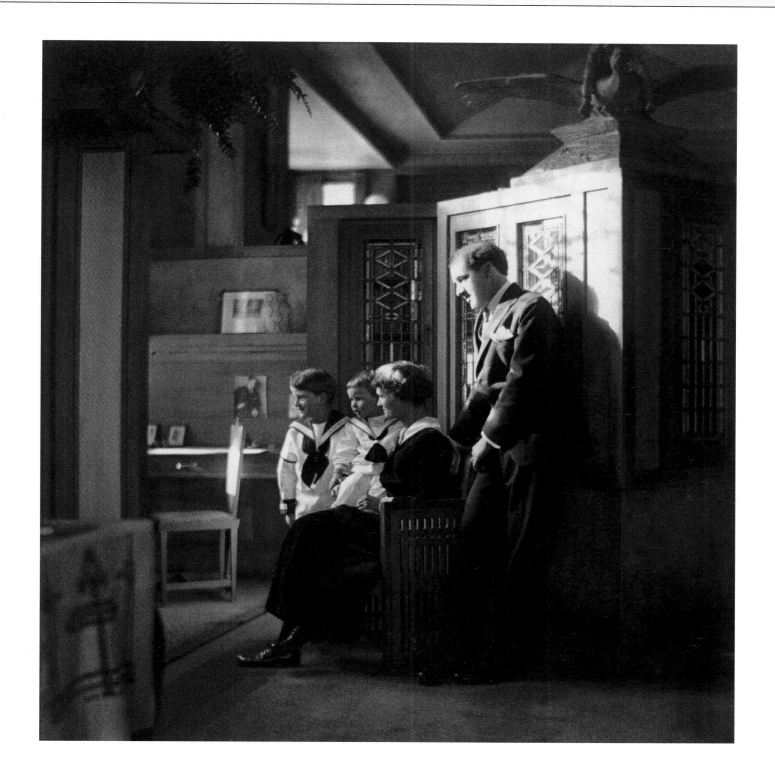

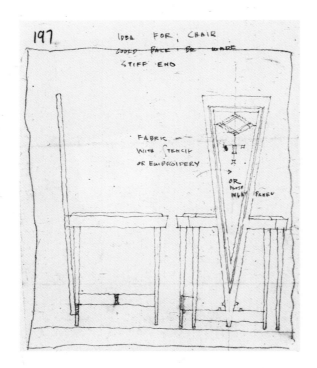

furniture for the house (now replaced by repro-ductions copied from the originals or based on documentary evidence), all with the angularity characteristic of the house itself. These include the two delicate triangular-backed chairs that Purcell described as "perhaps not 'exclamation points,' but 'surprise points' in the room"; box-shaped armchairs for the fireplace; a standing lamp; a fern stand; and a dictionary stand. How-ever, the Purcells also lived with furniture from their previous residences. For the semitransparent curtains of "a mouse colored French cheviot, very fine weave, almost like silk," Elmslie designed stencils, which Edna embroidered.[44]

Adopting an open plan within the house enabled Purcell and Elmslie to use natural light to great effect. Windows were positioned to transmit the sun's rays throughout the day, with striking and often decorative results.

Under the seven foot eave projection over the great East windows the sun comes in the first thing in the morning, and in the winter time since in Minnesota it stays close to the horizon all day, it slants into the room until noon. On summer evenings I have seen the orange red squares of setting sun sending ribbons of light down the whole length of the fifty odd feet of Living Room and flecking rose colored spots of ruddy color on the window mullion of the East window—shadow and sunshine [basking?] against the lavender light of evening climbing up the Eastern sky.[45]

For artificial light, Elmslie designed five metal pendant lights with glass half domes for the living room. They were made by the firm of Robert Jarvie in Chicago, well known for metalwork and furniture. The light from the pendants could be augmented by the standing lamp and reading lamps—and candles, if numerous guests were present.[46]

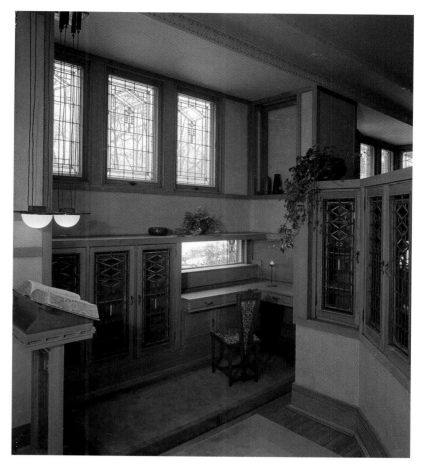

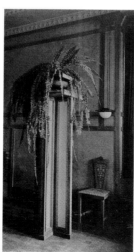

TOP

THE WRITING NOOK

LEFT

"SURPRISE POINT" CHAIR AND FERN STAND, ABOUT 1914

RIGHT

WRITING NOOK WITH FURNITURE AND PENDANT LIGHT FIXTURE, ABOUT 1914

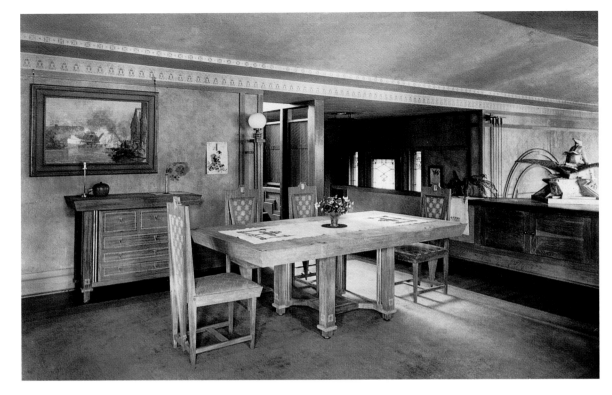

THE DINING ROOM

Purcell was fond of the European custom of eating out-of-doors in fine weather. To him, it symbolized freedom from the rigid conventions and habits imposed by decades of formal American living.

Ten thousand times ten thousand American families dine in the same spot, facing food in the center of the room with their backs to the windows while all the poetry and splendor there is flows by inviting as the still small voice of beauty but with no response. When what we eat and how we eat it become so important that we can't move the ceremony of it near the window or outdoors, something in life has become unreasonable.[47]

His own home encouraged flexibility in dining arrangements. The dining room suite used at Lake Place had been designed for the Catherine Gray house, and its green color did not match the scheme of the new house. But the three-table system allowed frequent dining on the back porch.

In January 1915, when the journal *Western Architect* photographed the Lake Place house, furniture Elmslie had designed for a Chicago

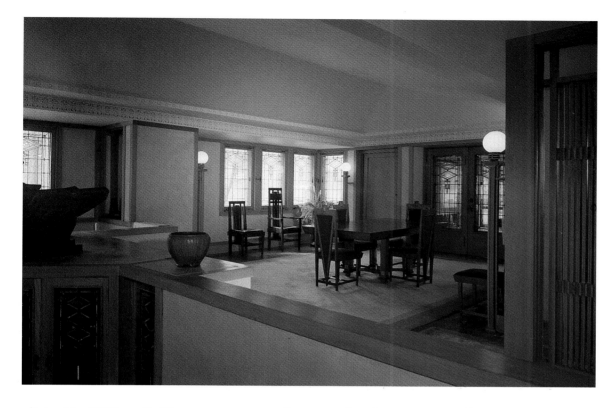

client, Mrs. William H. Hanna, was temporarily brought in. The mahogany suite—a table with detachable leaves and chairs similar to the surprise point chairs—made by John S. Bradstreet and Company of Minneapolis, showed "how splendid the room could be with suitable decorative equipment." A reproduction of the Hanna suite, complete with iridescent glass and art-glass inlays and silver-plated vertical rods, is now in the dining room along with two reproduction chairs from Purcell's green suite. Four permanent light standards provide atmospheric light, and Lawton Parker's framed painting *Island Lake* evokes Purcell's childhood summer home in northern Wisconsin.

For the prow, Purcell wanted a sculpture, and he approached Richard Bock, who worked frequently with Frank Lloyd Wright. Bock suggested the hero of Selma Lagerlöf's recent book, *The Wonderful Adventures of Nils*, about a boy who travels over Sweden on the back of a goose. In 1915, nearly a year after Purcell commissioned it, the patinated plaster sculpture of Nils Holgersson astride the goose was completed. A second, similar version (made by Bock about the same time as the first one) now sits on the prow, seemingly ready to take off.[48]

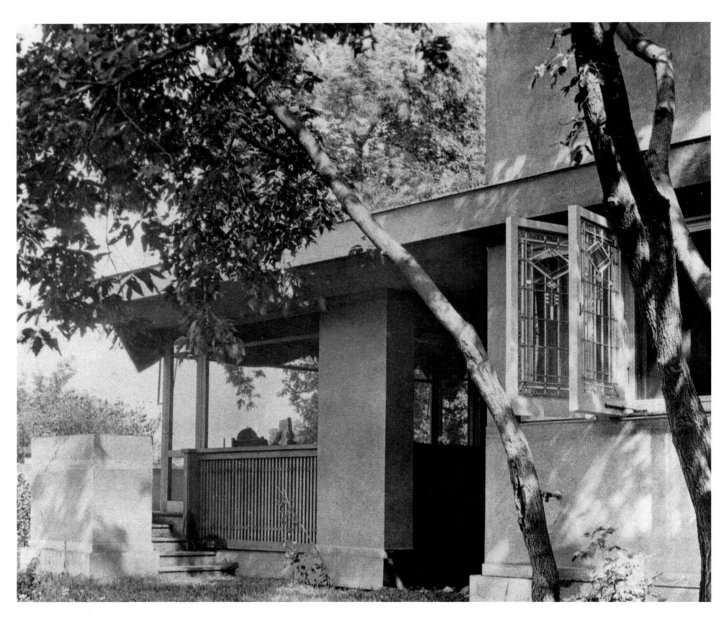

THE PORCH

Conveniently attached to the dining room, the back porch functioned as more than a summer eating area. This square, screened porch was a multipurpose outdoor room, equipped with a maid's call button, electrical outlets, a central art-glass light fixture (now in The Minneapolis Institute of Arts and replaced with a reproduction), and a porch swing. Here the Purcells enjoyed sunsets, Lake of the Isles, and their neighbors' gardens, untroubled by mosquitoes.

The second floor is reached by a stairway whose landing cantilevers over the side walkway. A window wall here provides another wraparound view, another glimpse of the lake and of the Gray Days and Gold motto below. The light fixture on the landing—a loose cluster of simple globes, textured with paint to diffuse the light—is one of the most strikingly modern features of the house.

The second floor exemplifies the economy of plan so important to Purcell, yet the spaces are remarkably generous. The small central hall's tented ceiling draws the eye upward and out the tall landing windows. The guest bedroom, on the left, also features a tented ceiling. This room has windows along two sides and a closet with a built-in washstand. The furniture is a reproduction of a painted bedroom suite designed and made in 1909 for the home of Charles A. Purcell, William's father.[49] To the right of the hall is the spacious, virtually unchanged bathroom,

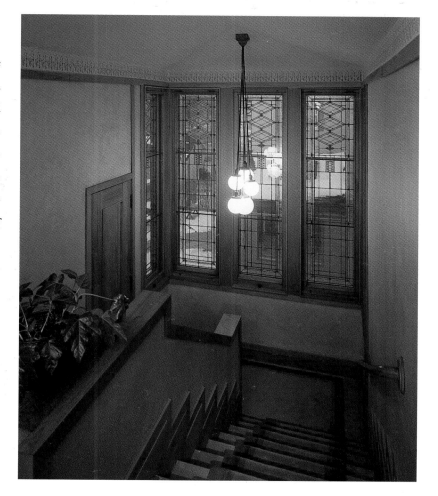

LANDING AND
LIGHT FIXTURE

57

GUEST BEDROOM,
WITH PHOTO OF
ANSON CUTTS, SR.

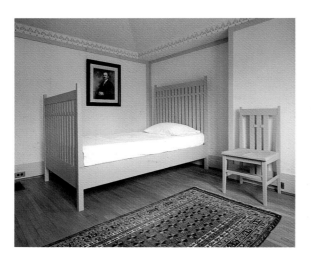

pleased with "the little lad's 'sleeping car' bed," Purcell describes it in "Own House Notes" as

all panelled about and with two tiny windows just at the pillow and a regular "berth light" and rolling, cloth shades just like the real ones. Underneath are great drawers for toy things and the footboard is a bookcase with a folding desk tucked away inside.[50]

with a floor of magnesite (a cementlike mixture of magnesium oxide, sawdust, and pigment), a large bathtub, and a view of Lake of the Isles.

The main second-floor space is the master bedroom suite. A grasscloth-covered folding screen in the center divides the bedroom from a small sitting room, or morning room, with a fireplace and east-facing windows. Two cedar storage bins in the floor, accessible by trapdoors, take advantage of space created by the tented ceiling below. In 1915, Purcell designed an ingenious built-in Pullman-style bed in the morning room for four-year-old James. Clearly

Besides improving on Purcell's childhood experience of Pullman cars—"breaking my neck" to look out the high windows[51]—the two small windows provided another of the unexpected links to the outdoors that are such an important aspect of this house. In early 1915, the Purcells adopted a second son, Douglas (born February 23, 1915), and Purcell envisioned the fireplace as the boys' corner, where they could enjoy being read to on winter evenings while snacking on prunes and crackers with milk.

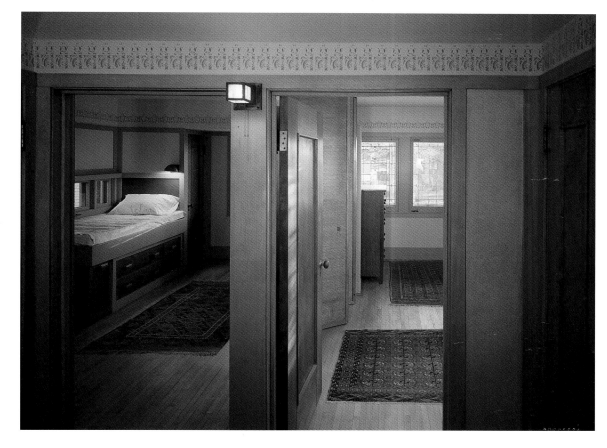

William and Edna's bedroom had a sleeping porch, considered almost a necessity in well-appointed homes of the time: "outdoor sleeping is done when the weather invites as always with the modern sleeping porch." [52] Their west-facing screened porch allowed the Purcells to breathe fresh air three seasons of the year, and it had a view toward the lake and Grandmother Gray's house. The twin brass beds could be easily rolled out, and back in, over a fold-down threshold. In winter, the many south-facing windows and the art-glass porch doors maintained the connection to nature.

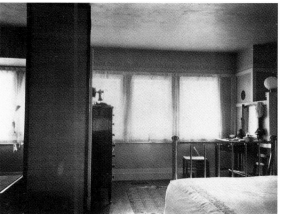

Purcell and Elmslie treated even the service areas of the house in new ways. They felt that since the rest of the house broke with convention, the service areas should also be rethought, and some challenges in the small house spurred them on.

The Purcells wanted a live-in maid. Until the First World War, hired help was still the norm for middle-class families. Maids were usually young white working-class women, often immigrants from Ireland, Germany, or Scandinavia. As the only permanent servant in the house, the Purcells' maid would probably have had duties ranging from furnace stoking to child care. Although maids were often treated as one of the family, a division between social classes remained, even in the Purcells' forward-thinking modern family.

The tight plan of the house did not allow for a separate servant's stair or wing. Preliminary plans show the maid's bedroom in an unfortunate spot in the basement (where her bathroom was ultimately located), but Purcell ingeniously found a way to have the maid both more comfortable and more accessible to the family. Her bedroom was situated at the northwest corner of the second floor, with access from the landing between the first and second floors. Opening a door on the landing, the maid ascended six steps to her room, which had a closet and sink. Though small (only about 9 × 11 feet), the room was agreeable; the maid had a view of Lake of the Isles through two art-glass windows, and plenty of light to do needlepoint or darning. Today the maid's room, which looks as it did in 1913, is used as living quarters for the house caretaker.

The maid's work was made easier with a spacious kitchen that met the modern standards of 1913. It had excellent storage and preparation areas, good ventilation, and a view of the lake through three art-glass windows. The brick-red and brown magnesite floor was easy to keep clean. The Purcells had the latest in appliances, including a gas stove and a steel-lined icebox,

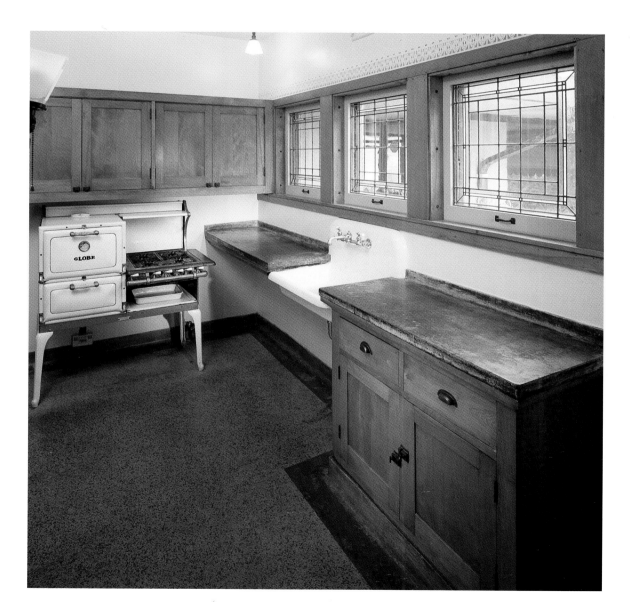

VIEW OF THE
NORTH SIDE,
SHOWING THE
CANTILEVERED
LANDING,
ABOUT 1914

probably similar to the period stove and icebox now in place. Through a panel near the side entry, the iceman deposited ice into the back of the icebox. The electric call system, or annunciator, with buttons throughout the house, rang in the kitchen and kept the maid apprised of the family's needs. This mostly unaltered kitchen provides a rare look at a state-of-the-art service area of the early twentieth century.

Another convenience for the maid was a double door from the kitchen into the dining room. Throughout the day, the swinging door was used. When serving the Purcells or their guests, however, the maid activated a spring-loaded pocket door by stepping on a button in the kitchen floor. Then she could move through the doorway while holding things in both hands. On the dining room side, another button allowed her to close the door and hide the kitchen from view.

By locating the service areas in the northern part of the house, Purcell and Elmslie ensured that the maid and other hired help could perform most of their duties without disturbing the family. A north service door gives access in three directions. The basement stairs are directly ahead; to the right, several steps lead up to the kitchen; and at the left is a small phone booth, which also opens into the main entry of the house. Complete with folding seat, writing surface, electric light, and small art-glass window, the phone booth has two doors, allowing the user to close off one or both sides for privacy.

Purcell rejected the status quo for basements and their equipment. For example, his basement has a higher ceiling than the norm.[53] Wanting to be innovative, Purcell insisted on the latest in heating and cooling systems, even though it meant a little discomfort because they still

had some shortcomings. The Peck-Williamson underfeed gravity furnace was the most advanced coal furnace of the time but difficult to stoke. (A gas furnace replaced it in later years.) Connected to the furnace were an early air-conditioning system and a primitive humidifier.[54] The great amounts of circulating air these systems required is attested to by the large ducts in the basement and the oversized vents and returns visible throughout the house.

Leaving Lake Place

From the attention to detail and from Purcell's writings, it is clear that the Lake Place house was a labor of love for both William and Edna. Sadly, the Purcells lived in their dream house for only a few years. After the First World War began, Purcell and Elmslie's architectural commissions declined. In 1916, probably thinking of his family's future, Purcell took a position as advertising manager for Charles O. Alexander's industrial leather belting firm in Philadelphia. By 1918, the entire family had moved to Philadelphia, and Purcell put the Minneapolis house up for sale.[55]

Purcell's employment with Alexander Brothers proved unhappy in the long run, and in 1919 the family moved to Portland, Oregon. After his association with George Elmslie ended in 1921, Purcell ran an architectural office for another ten years.[56] In 1931, he learned he had tuberculosis and entered a sanatorium in Banning, California, staying until 1935. During that period he and Edna divorced, and their son Douglas died suddenly of meningitis. Catherine Gray, who had moved to Portland to be near her grandson, died in 1934. Following these life-changing events, Purcell cut back significantly on his architectural work and moved to Pasadena, California, where he lived from 1936 until his death in 1965.[57]

WILLIAM GRAY PURCELL, ABOUT 1920

TOP

ANSON CUTTS, SR.,
AND EDNA CUTTS
IN FRONT OF THEIR
HOME, PROBABLY
1930s

BOTTOM

ANSON CUTTS, JR.,
"JUST BACK FROM
CAMBRIDGE," 1931

THE HOUSE
AFTER PURCELL

In May 1919, the Edna S. Purcell house was purchased by Anson Bailey Cutts, Sr., for fifteen thousand dollars. Anson Cutts (1866–1949) served as chief rate clerk of James J. Hill's Great Northern Railroad from 1890 to 1892 and then, for many years, as passenger traffic manager for the Minneapolis and St. Louis Railroad. His wife, Edna Browning Stokes (1875–1976),[58] studied voice and occasionally gave private concerts. The Purcell house may have appealed to Edna Cutts because of its suitability for musical performances.

The Cuttses had one son, Anson B. Cutts, Jr. (1905–85). He attended Yale University and earned a master's degree in art and architectural history at King's College, Cambridge. Throughout his life, Anson Cutts, Jr., pursued his interest in painting and writing. During ten years in the 1950s and early 1960s as a cultural critic for a

Phoenix newspaper, he became a visitor to Taliesin West, Frank Lloyd Wright's winter home in the Arizona desert. In 1962, he moved back to the Lake Place house in Minneapolis to care for his ill mother.[59]

In 1953, Purcell and Elmslie were honored with an exhibition at the Walker Art Center in Minneapolis, and Purcell resumed contact with Edna Cutts around that time. He knew the Lake Place house was a regular stop for architecture students, and he thought often about the eventual fate of his most complete progressive dwelling. The Cutts family had refrained from substantially changing the house, except for building a garage in the 1920s and filling up the reflecting pool in later years. In a letter to Edna Cutts in 1961, Purcell thanked her for opening the house to students and expressed his wish to be involved in preserving the house.

Since the Walker Gallery Exhibit in 1953 I have been eager to find a way to maintain it as you have done—to save it from unwise remodeling. Professor Torbert's comments have lead [sic] me to believe it might become a West Side University Center for the arts....You may have family plans for the future. If there is a chance for a public or semi-public use for this building, I would like to discuss taking a practical share now and by bequest in any project that may develop.[60]

At one point, Purcell even sketched out a scheme that called for his purchase of adjacent lots that would be cleared in order to expand the space around the "Little Joker." His plan extended to setting up a trust fund for the house, having another set of the Hanna furniture built, renting to young couples at low rates, and allowing public entrance twice a week.[61]

This was not to be. But by the time of Purcell's death in 1965, Anson Cutts, Jr., was beginning to think about a public owner for the house that

his family had by all indications lived in happily for decades. In 1985, he bequeathed the house to the Minneapolis Society of Fine Arts (the parent organization of The Minneapolis Institute of Arts), along with funds for its restoration. To represent his parents, he left in the house several objects belonging to the Cutts family: a tall-case clock in the entrance hall, a photograph of Anson Cutts, Sr., and a case of golf trophies won by Anson senior.

The fate of his house would have pleased William Gray Purcell. From 1987 to 1990, The Minneapolis Institute of Arts restored and furnished the house, and in September 1990 it was opened to the public as the Purcell-Cutts house. On the National Register of Historic Places, this modern house of 1913 is a local and national landmark, delighting architecture students and the public alike. Purcell and Elmslie's thoughtful and inspired solutions to the problems posed in designing a small yet spacious house for a modern family make this residence one of the most important works of Prairie School architecture.

The opening of the restored Purcell-Cutts house has spurred the growth and development of the Prairie School collection at The Minneapolis Institute of Arts. Now among the best in the country, it includes objects by Sullivan, Wright, Purcell and Elmslie, and Maher. Writing in 1952, Purcell foresaw a widespread appreciation of Prairie School architecture, though perhaps not in his lifetime.

There has always been a yearning within me to design a full equipment of furniture for this house. Some day I have thought I might even buy it back and do this very thing, one of those dreams, but at that, more reasonable than restoring an old Colonial, for this house is in step with the best of today, indeed watching the non-functional streamlinism of 1940 now on the zoom, it is not unlikely that "The Little Joker" will come into its best days another quarter century hence.[62]

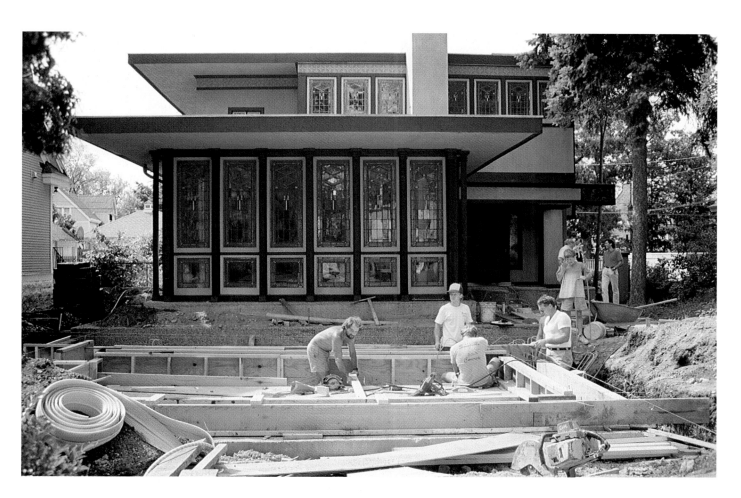

RESTORATION OF
THE REFLECTING
POOL, 1990

Funds for the restoration of the Purcell-Cutts house were provided by the Anson B. Cutts, Jr., Fund; Gabberts Furniture and Design Studio; Kenneth and Judy Dayton; the Friends of the Institute; and the Decorative Arts Council.

NOTES

1. For more information on the development of the lake district of Minneapolis, see David A. Lanegran and Ernest R. Sandeen, *The Lake District of Minneapolis: A History of the Calhoun-Isles Community* (St. Paul, Minnesota: Living Historical Museum, 1979).

2. William Gray Purcell, Parabiographies for 1913 (1952), p. VII-12, William Gray Purcell Papers, Northwest Architectural Archives, University of Minnesota Libraries, Minneapolis. The Parabiographies are year-by-year accounts of the firm's projects and commissions, written by Purcell in the 1940s and 1950s.

3. The best text on the Owatonna Bank is Larry Millett, *The Curve of the Arch: The Story of Louis Sullivan's Owatonna Bank* (St. Paul: Minnesota Historical Society Press, 1985).

4. See David Gebhard, "William Gray Purcell and George Grant Elmslie and the Early Progressive Movement in American Architecture from 1900 to 1920" (Ph.D. dissertation, University of Minnesota, Minneapolis, 1957), pp. 22–23. Purcell strongly believed that good architecture should be available to everyone; probably the firm's most successful built small house design was for C. T. Bachus, Purcell's piano tuner, at 212 West 36th Street in Minneapolis (1915). See Mark Hammons, "Purcell and Elmslie, Architects," in *Minnesota 1900: Art and Life on the Upper Mississippi, 1890–1915*, edited by Michael Conforti (Newark: University of Delaware Press; London and Toronto: Associated University Presses in association with The Minneapolis Institute of Arts, 1994), pp. 247–48.

5. Gebhard, pp. 10–11.

6. See H. Allen Brooks, *The Prairie School: Frank Lloyd Wright and His Midwest Contemporaries* (1972; New York and London: W.W. Norton, 1996), pp. 7–13, for the history of the term "Chicago School" and the eventual usage of the term "Prairie School" to describe the generation that followed Sullivan.

7. Gebhard, p. 89. Later Wright expanded his home and built an office there, which he used until 1909. Ann Abernathy, *The Oak Park Home and Studio of Frank Lloyd Wright* (Chicago: Frank Lloyd Wright Home and Studio Foundation, 1998), pp. 4–7.

8. Gebhard, pp. 90–91; Hammons, "Purcell and Elmslie," pp. 221–22. For more on Purcell's life at Island Lake, see William Gray Purcell, *St. Croix Trail Country: Recollections of Wisconsin* (Minneapolis: University of Minnesota Press, 1967).

9. Purcell, *St. Croix Trail Country*, p. ix; Gebhard, pp. 90–92.

10. Gebhard, pp. 93–94; Hammons, "Purcell and Elmslie," p. 222.

11. Gebhard, p. 72, says that Elmslie was born on his father's small farm near the town of Huntley, Scotland, in 1871. Also see "Purcell, Feick and Elmslie Biographical," William Gray Purcell, Personal Records (August 1951), William Gray Purcell Papers. I am using Mark Hammons's birth date for Elmslie of 1869. Frank Lloyd Wright had joined Adler and Sullivan's firm in 1887 after working for Joseph Lyman Silsbee, a Chicago architect of Shingle Style and Queen Anne buildings, who employed both George Grant Elmslie and George Washington Maher during the time Wright was with him.

12. During Sullivan's slow time, Elmslie encouraged Purcell to submit a design for a village library for the *Brickbuilder*, which won fifth place. Gebhard, pp. 96–97.

Purcell worked for John Galen Howard in San Francisco and for Bebb and Mendel and A. Warren Gould in Seattle. Gebhard, pp. 98–101.

13. Their trip took them to Italy, Greece, and Asia Minor and also—which was unusual at the time—to many northern European and Scandinavian countries. They sought out the architects Hendrik Petrus Berlage (1856–1934) in Holland, Martin Nyrop (1849–1921) in Denmark, and Ferdinand Boberg (1860–1946) in Sweden. Gebhard, p. 102; Hammons, "Purcell and Elmslie," p. 223.

14. Parker did some of her own projects while with the firm and later became a successful independent architect. Hammons, p. 233. For more information on members of "the Team," see Gebhard, pp. 50–51 n. 6, and Hammons, "Purcell and Elmslie," pp. 233–35.

15. Several different accounts exist as to exactly when Elmslie joined the firm of Purcell and Feick. It is generally agreed that Elmslie provided much informal advice and assistance to the young firm from 1907 to 1909. Brooks, p. 187, says Elmslie joined the firm in 1909. Hammons, "Purcell and Elmslie," p. 236, states that Elmslie left Sullivan's firm in 1910 and joined Purcell and Feick then, and this is corroborated in "Purcell, Feick and Elmslie Biographical," William Gray Purcell, Personal Records (August 1951), William Gray Purcell Papers. Millett, pp. 102 and 124–25, recounts Elmslie's being let go by Sullivan on December 4, 1909, and moving to Minneapolis early the following year. Feick left the firm in 1913 to pursue engineering in his hometown of Sandusky, Ohio. "Purcell, Feick and Elmslie Biographical"; Gebhard, p. 43. Some records also indicate that the firm of Purcell and Elmslie was dissolved in 1922.

16. Parabiographies for 1907, p. 4.

17. Ibid., p. 11a. Purcell recounts that Wright said only "Twenty-five years from now you will see plainly in these drawings what I see in them."

18. Ibid., p. 9. See also Gebhard, pp. 110–15, and Hammons, "Purcell and Elmslie," pp. 230–31.

19. Parabiographies for 1907, p. 11. Purcell notes that he lived there "for the year before I was married," but drawings for the furniture he designed for his first "own home" are dated April 1909. See the working drawings for Job Number 5, William Gray Purcell Papers. It is thought that William and Edna lived with Catherine Gray until sometime in 1909, when they moved into 2311 Humboldt Avenue South, Flat D.

20. Working drawings for Job Number 51, sheets 11, 14, 15, William Gray Purcell Papers, show living room chairs identical to furniture designed for the Catherine Gray house, as well as a similar bed with seat and a sideboard with art-glass panels.

21. See Hammons, "Purcell and Elmslie," pp. 244–47, for a detailed discussion of the Powers house.

22. See The Western Architect, January 1913, January 1915, and July 1915. Sections of these were reissued as The Work of Purcell and Elmslie, Architects, with an introduction by David Gebhard (Park Forest, Illinois: Prairie School Press, 1965).

23. "Own House Notes," Job File 197, p. 5, William Gray Purcell Papers.

24. "Own House Notes," pp. 9–10. Secondary sources on the house have consistently named Douglas as the older son, adopted in 1911. However, primary source material in the William Gray Purcell Papers at the Northwest Architectural Archives supports the view that James was the older son. See Edna Summy Purcell, Correspondence file.

25. "Own House Notes," p. 1.

26. Ibid.

27. Parabiographies for 1913, p. VII-4.

28. Ibid.

29. Ibid.

30. He was inspired in this type of siting by the town planning endeavors of Walter Burley Griffin, a Prairie School architect from Chicago who would make his mark in Mason City, Iowa, and later as the city planner for the new town of Canberra, Australia. See Parabiographies for 1913, p. VII-5.

31. For more information on the plantings, see Appendix A, "Site and Landscape Inventory," in *Historic Structures Report for the Edna S. Purcell House Restoration*, a report prepared for the Minneapolis Society of Fine Arts by MacDonald and Mack Partnership, August 1987. (A copy of this report can be consulted in the Art Research and Reference Library at The Minneapolis Institute of Arts).

32. This eave was insufficiently supported, necessitating structural restoration later. See Richard L. Kronick, "The Underachieving Cantilever," *Old House Journal* 30, no. 3 (May/June 1997): 40–45.

33. For a description of Bradstreet's method, see Michael Conforti and Jennifer Komar, "Bradstreet's Craftshouse: Retailing in an Arts and Crafts Style," in *Minnesota 1900*, p. 69, and Michael P. Conforti, "Orientalism on the Upper Mississippi: The Work of John S. Bradstreet," *Minneapolis Institute of Arts Bulletin* 65:16–17.

34. "Own House Notes," pp. 1–2.

35. Elmslie had moved back to Chicago in 1912, shortly after the death of his wife of two years, Bonnie Hunter. See Millett, pp. 126–30. He had opened an office in the People's Gas Building and corresponded regularly with Purcell about the firm's jobs. Elmslie's sisters' number had been the "office" up until that time. Gebhard, p. 273. Letters and sketches preserved in the William Gray Purcell Papers illustrate the cooperative process that led to the final scheme. This process (and the house in general) is well interpreted by Mark Hammons in his report "Historical Considerations," in *Historic Structures Report for the Edna S. Purcell House Restoration*, pp. 16–83.

36. Correspondence file, Job Number 197, William Gray Purcell Papers. Elmslie used ditto marks to indicate his second and third use of the word *continuous*.

37. "Own House Notes," p. 2.

38. In 1921 the Cuttses expressed interest in returning the portrait to Purcell, who replied in a letter to Frederick Strauel, one of Purcell and Elmslie's associates still in Minneapolis, that it had chiefly had sentimental value for him, and if they wished to cover it over carefully that would be fine with him. Purcell to Strauel, January 18, 1921, Correspondence file, Job Number 197, William Gray Purcell Papers. The painting's being displayed at the World's Columbian Exposition is mentioned by Hammons, "Purcell and Elmslie," p. 255. The painting was repaired during the restoration of the house.

39. Estimate from E. L. Sharretts's Mosaic Art Shops, Correspondence file, Job Number 197, William Gray Purcell Papers. The geometric motifs could be read as wheat sheaves or other prairie plants. In late 1913, the house had to be enclosed to protect the interior from cold weather. Sharretts, not yet finished making the Elmslie designs, brought over every spare piece of glass to enclose the house, including bright blue, yellow, green, and red glass; sheets of frosted and office partition glass; and diaper church panes with angels, mottoes, and shields. Purcell called the result "a sight for an asylum of trolls." Parabiographies for 1913, p. VII-12.

40. "Own House Notes," p. 3.

41. Gladys M. Hamblin, "Unique Wall Painting for W. G. Purcell Home," Minneapolis *Tribune*, November 15, 1914, page(?) 15, and Parabiographies for 1913, pp. VII-16 to VII-18.

42. "Own House Notes," p. 3.

43. Ibid., p. 8.

44. Parabiographies for 1913, p. VII-11. Included in working drawings for Job Number 197, William Gray Purcell Papers, are the original stencil pattern and specifications for colors.

45. "Own House Notes," pp. 6–7.

46. Ibid., pp. 5–6.

47. Ibid., p. 4.

48. While waiting for Nils, Purcell was lent a sculpture of a faun from Bock's studio, which appears in the *Western Architect* photos from 1913–14. See Richard Bock, *Memoirs of an American Artist: Richard W. Bock* (Los Angeles: C. C. Publishing Company, 1989), pp. 102–3. Purcell took the original sculpture when he moved out of the Lake Place house. It was damaged in a train wreck on the move to Pennsylvania, and Purcell had Bock make another version for his 1921 house in Portland, Oregon.

49. This suite of furniture was previously thought to be from the Catherine Gray house, but new material (donated by David and Patricia Gebhard) now in the Northwest Architectural Archives strongly suggests otherwise. In a folder labeled "Furniture for Catherine Gray" are two interior photos of Purcell's father's house. The first shows the ground-floor fireplace wall, with a mural by Fleury of Charles Purcell's birthplace in the Catskills; the other is of the painted suite, with Purcell's notations on the back indicating that the picture is of the house on Bonnie Brae in River Forest. The address of Purcell's father's house was 601 Bonnie Brae.

50. "Own House Notes," p. 10.

51. Parabiographies for 1913, pp. VII-13 to VI-14.

52. Ibid., p. 10.

53. Parabiographies for 1913, p. VII-6.

54. Ibid., pp. VII-8 to VII-9.

55. It is not certain when Edna and the children moved to Philadelphia; they could have moved out before Purcell. Purcell describes living in the house in the winter of 1917–18, though he was traveling back and forth to Philadelphia from 1917 to 1919. See Parabiographies, 1913, pp. VII-7, VII-10. Hammons, "Purcell and Elmslie," p. 269, states that the Purcell family moved to Philadelphia in 1916; he gives more information on Purcell's work in Philadelphia on pp. 269–72.

56. Purcell built a summer house—very Japanese in feeling—for his family in Rose Valley, Pennsylvania, in 1919, and one in Portland, Oregon, in 1921. See files for Job Numbers 368/381 and 607, William Gray Purcell Papers.

57. For more on the later life of Edna and the two boys, see Correspondence file, Edna Summy Purcell, William Gray Purcell Papers. Purcell married Cecily O'Brien (1903–60), whom he met while in the sanatorium, in 1935. For a concise account of Purcell's later life, also see Hammons, "Historical Considerations," pp. 37–43.

58. A contemporary profile of Anson Cutts, Sr., can be found in Marion D. Shutter and J. S. McLain, eds., *Progressive Men of Minneapolis* (Minneapolis: Minneapolis Journal, 1897), p. 119.

59. Anson Cutts, Jr., to Purcell, November 17, 1962, Correspondence file, Job Number 197, William Gray Purcell Papers. See also "Critic, Author Anson Cutts Jr. Dies at Age 80," Minneapolis *Star and Tribune*, May 7, 1985, and the Cutts family file, Minneapolis Room, Minneapolis Public Library.

60. Purcell to Edna Cutts, June 2, 1961, Correspondence file, Job Number 197, William Gray Purcell Papers.

61. Undated sketch with notes, Correspondence file, Job Number 197, William Gray Purcell Papers.

62. Parabiographies for 1913, p. VII-4.

PRAIRIE SCHOOL AND
MIDWESTERN ARTS & CRAFTS

Catalogue
of Objects

Compiled by
CORINE A.
WEGENER

THIS CATALOGUE showcases objects in the Prairie School collection of The Minneapolis Institute of Arts, many of them designed by architects striving for unified, organic design throughout their buildings. Early twentieth-century Arts and Crafts pieces made or designed in the Midwest are also included. Their simple shapes, organic motifs, and handmade character complemented the progressive architecture of the time, and architects and clients often chose locally made Arts and Crafts objects for their Prairie School interiors. Organizations such as the Handicraft Guild of Minneapolis pursued some of the same progressive ideals important to William Purcell and other Prairie School architects. They wanted to create new, thoughtful designs for things that average Americans would use every day. ¶ The quotations from Purcell and Elmslie are from the William Gray Purcell Papers, in the Northwest Architectural Archives. ¶ Full references to works cited as Relevant Texts are given in the Bibliography.

1.

LUNETTE AND DECORATIVE PANELS

1884–85

DESIGNER: Louis H. Sullivan (American, 1856–1924)

MAKER: Northwestern Terra Cotta Works (Norweta), Chicago, 1884–1956

Painted terra-cotta

Lunette sections: (three) H 18½ in., W 24 in., D 7⅞ in., (one) H 6½ in., W 11¾ in., D 8⅛ in. (one is shown); decorative panels: (two) H 29¼ in., W 17¼ in., D 9½ in., (one) H 29¼ in., W 14½ in., D 9½ in. (one is shown)

From the Scoville Building, Chicago (demolished 1974); Adler and Sullivan, architects

Gift of the Department of Environmental Affairs, U.S. Government 77.23.1–13

LOUIS H. SULLIVAN

Louis Sullivan designed these terra-cotta panels for the exterior of the Scoville Building in Chicago, one of the Adler and Sullivan firm's earliest commercial commissions. Sullivan wanted to develop and promote an architecture suited to late nineteenth-century American life. He rejected historical styles, believing that buildings should be appropriate to their sites and to the needs of the people who used them. He favored using ornamentation to unify a building's design, and his own work often featured plant forms of the American prairie. Sullivan inspired a younger generation of architects to apply his principles to all types of buildings, a movement that came to be known as the Prairie School. These architects, who included Frank Lloyd Wright, William Gray Purcell, and George Grant Elmslie, successfully applied organic principles to domestic and commercial buildings in the years between 1895 and 1918.

The Scoville Building was a difficult commission for Adler and Sullivan, requiring them to remodel an existing Adler structure to accord with a new, much larger addition. The terra-cotta pieces shown here formed part of the organic decoration of stylized plants with which Sullivan tied the two buildings together. For the decorative panels, he used geometric palmetto leaves and flowers, repeating the same pattern in all the panels, which were grouped in threes above the fourth-story window lintels. The lunette, which ornamented the arch above the windows of the top (fifth) story, has an undulating design of ferns unfurling. Pictured here before conservation, under layers of gray paint, the lunette is displayed in the gallery as originally conceived, with its terra-cotta surfaces fully revealed.

Similar architectural fragments from the Scoville Building are in the collection of the Metropolitan Museum of Art in New York.

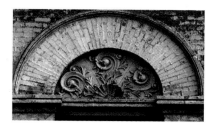

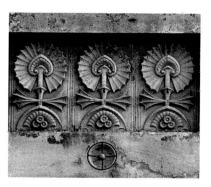

RELEVANT TEXTS

Morrison, *Louis Sullivan*, p. 266.

Sprague, "Sullivan's Scoville Building," pp. 16–23.

Weingarden, "Naturalized Nationalism," pp. 41–68.

PROVENANCE

The Scoville Building (James W. Scoville)

Department of Environmental Affairs, U.S. Government

TOP TO BOTTOM

LUNETTE, DETAIL OF THE SCOVILLE
BUILDING

DECORATIVE PANELS, DETAIL OF THE
SCOVILLE BUILDING

SCOVILLE BUILDING, CHICAGO

2.

ORNAMENTAL RELIEF 1891–92

DESIGNER: Louis H. Sullivan (American, 1856–1924)

Gilt plaster

H 27½ in., W 27¼ in., D 1¼ in.

From the proscenium arch of the Schiller Building Theater (later the Garrick Building), Chicago (demolished 1961); Adler and Sullivan, architects

Gift of Roger G. Kennedy 98.256.4

Combining an office tower and a theater, the seventeen-story Schiller Building (1890–92) was the tallest building the firm of Adler and Sullivan ever constructed. The 1,286-seat theater filled the central portion up to the sixth floor. For the ornamental plaster vaults and panels, Sullivan planned a repeating pattern of stars surrounded by interlocking circles with lush vines and leaves. This theme continued in the large and ornate proscenium arch, which foreshadows the spectacular archway of Adler and Sullivan's Transportation Building for the World's Columbian Exposition of 1893. The color scheme of the Schiller Building Theater was green and gold. As in all Sullivan's architecture, the ornamental motif was repeated throughout the building, both inside and out, to achieve an integrated design.

Other fragments of the Schiller Building are now in the Art Institute of Chicago, including sections of plaster ornament from the banquet hall frieze, the proscenium vault, and the balcony face, and blocks of stringcourse in terra-cotta from the first-floor loggia.

RELEVANT TEXTS

Morrison, *Louis Sullivan*, pp. 61, 126–27, 130–31, 274, pl. 59.

Saliga, *Fragments of Chicago's Past*, pp. 118–25, 136–38.

Spencer, *The Prairie School Tradition*, p. 26.

PROVENANCE

The Schiller Building (A. C. Hesing)

Roger G. Kennedy

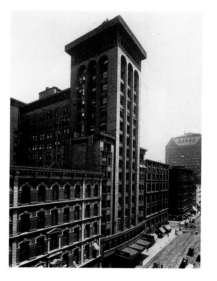

TOP TO BOTTOM

SCHILLER BUILDING, CHICAGO

SECTION OF THE PROSCENIUM ARCH
FROM THE SCHILLER BUILDING THEATER

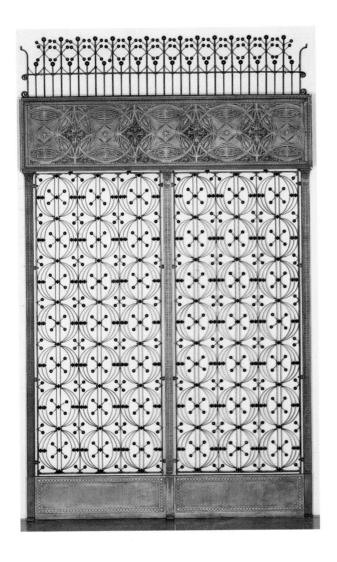

3.

PAIR OF ELEVATOR GRILLES, FRIEZE, AND OVERGRILLE about 1893

DESIGNER: Louis H. Sullivan (American, 1856–1924)

Cast iron, wrought iron, copper-coated wrought iron

H 118 in., W 67 in.

From the Chicago Stock Exchange Building, Chicago
(demolished 1972); Adler and Sullivan, architects

The John R. Van Derlip Fund 92.2

The Chicago Stock Exchange Building, for which these grilles were made, was one of Adler and Sullivan's last commissions before the firm dissolved in 1895. Frank Lloyd Wright, who left Sullivan's office in 1893, and George Grant Elmslie were both draftsmen with the firm at the time.

This grille design was used on floors three through thirteen. The repeating motif of tiny spheres carried on the arms of an X within ovals inside a circle is echoed in the elaborate botanical frieze above the grille and in the overgrille. Sullivan conceived this design as a series of "seed germs" bursting from their pods, an idea found in his prose poem "Inspiration," of 1886, in which he compared the metamorphosis of a seed into a plant to that of basic forms into a structure. In using what he knew as the smallest organic components, Sullivan produced a design far ahead of its time: it resembles the models of atomic structure that influenced object design of the 1950s and 1960s.

The trading room of the Chicago Stock Exchange Building was installed at the Art Institute of Chicago in 1976–77, and the archway of the Stock Exchange façade now stands on the institute's grounds. The Art Institute of Chicago also has a bank of elevator grilles from the first floor and a pair from one of the upper floors that is similar to the Minneapolis pair. Other elevator grilles can be seen at the High Museum of Art in Atlanta, Georgia, the Metropolitan Museum of Art in New York, and the Victoria and Albert Museum in London.

RELEVANT TEXTS

Saliga, *Fragments of Chicago's Past*, pp. 139–41.

Spencer, *The Prairie School Tradition*, p. 32.

Twombly, *Louis Sullivan*, p. 317.

Victoria and Albert Museum, *Art and Design in Europe and America*, pp. 166–67.

Vinci, *The Trading Room*, pp. 21–23.

Volpe and Cathers, *Treasures of the American Arts and Crafts Movement*, pp. 135–37.

PROVENANCE

Chicago Stock Exchange Building (Ferdinand W. Peck)

David B. Diny

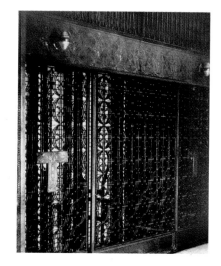

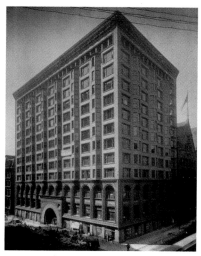

TOP TO BOTTOM

CHICAGO STOCK EXCHANGE ELEVATOR

CHICAGO STOCK EXCHANGE BUILDING

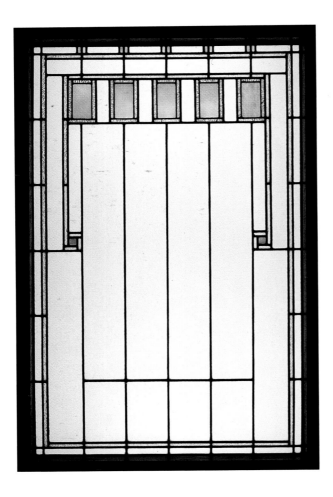

4.

WINDOW 1907–8

DESIGNERS: Louis H. Sullivan (American, 1856–1924) and George Grant Elmslie (American, b. Scotland, 1869–1952)

Glass, lead caming

H 43³⁄₁₆ in., W 27³⁄₈ in.

From the Henry B. Babson house, Riverside, Illinois (demolished 1960); Louis Sullivan, architect

The Modernism Collection, gift of Norwest Bank Minnesota 98.276.1

One of Sullivan's best-known residential commissions was the Henry B. Babson house, built in 1907–8 in Riverside, Illinois. George Grant Elmslie, Sullivan's chief draftsman at the time, excelled at progressive house design and worked extensively on the Babson project. This window is from a window wall of Elmslie's design. Uncharacteristically, he kept to linear geometric patterns and limited the colors to soft purple and translucent white punctuated with two small green squares. The windows for the Harold C. and Josephine Crane Bradley house in Madison, Wisconsin (1909), also by Sullivan's firm and chiefly from Elmslie's hand, are similar.

Elmslie was Henry Babson's main contact with Sullivan's firm, and when Babson wanted to alter his house four years later he entrusted Elmslie and his new partner, William Gray Purcell, with the work. Purcell and Elmslie designed new furniture for the house, including a tall-case clock and pair of andirons (now at the Art Institute of Chicago) and a box chair (see no. 21).

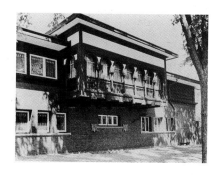

HENRY B. BABSON HOUSE, RIVERSIDE, ILLINOIS

RELEVANT TEXTS

Brooks, *The Prairie School*, pp. 141–44, 146, 153, 197.

Legler, *Prairie Style*, pp. 24–25, 84–87.

Twombly, *Louis Sullivan*, pp. 390–91, 393, 395, 414, 422.

EXHIBITIONS

Modernism at Norwest, Norwest Center, Minneapolis, 1989–90

Milestones of Modernism, 1880–1940: Selections from the Norwest Collection, The Minneapolis Institute of Arts, 1999

PROVENANCE

Norwest Corporation, Minneapolis

5.

WEED HOLDER about 1895–1900

DESIGNER: Frank Lloyd Wright (American, 1867–1959)

MAKER: James A. Miller and Brothers, Chicago, 1889–at least 1903

Copper

H 28 in., W 4¼ in., D 4¼ in.

The Modernism Collection, gift of Norwest Bank Minnesota 98.276.2

Like his Prairie School contemporaries, Wright designed not only houses but also almost everything in them, in order to achieve a unified effect in harmony with the architecture. Besides integral features such as stained-glass windows and built-in furniture, he designed freestanding furniture, textiles, and lighting fixtures. In Wright's case, this was a way to exercise control and, often, to impose his own preferences on the finished home.

Wright designed this weed holder shortly after establishing his own architectural practice in 1893. He used it in several of his interiors, including the octagonal library in his own studio in Oak Park (1898) and the dining room of the Susan Lawrence Dana house in Springfield, Illinois (1902). The unusually slender shape was meant to accommodate the prairie plants of the Midwest.

Approximately ten weed holders are to be found in public and private collections, including the Carnegie Museum of Art in Pittsburgh and the Metropolitan Museum of Art in New York.

RELEVANT TEXTS

Duncan, *Modernism*, p. 50.

Hanks, *The Decorative Designs of Frank Lloyd Wright*, pp. 69–70.

Spencer, *The Prairie School Tradition*, p. 51.

Volpe and Cathers, *Treasures of the American Arts and Crafts Movement*, pp. 134–35.

EXHIBITIONS

Modernist Metalwork, 1900–1940, Norwest Center, Minneapolis, 1996–97

Forging a New Century: Modernist Metalwork, 1880–1940, Denver Art Museum, 1998–99

PROVENANCE

Norwest Corporation, Minneapolis

FRANK LLOYD WRIGHT

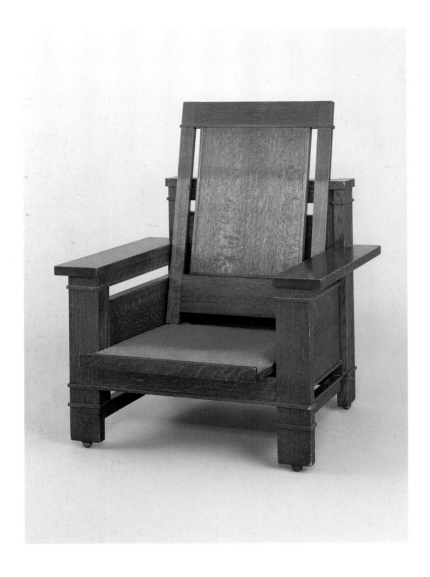

6.

EASY CHAIR about 1903
DESIGNER: Frank Lloyd Wright
(American, 1867–1959)
MAKER: Attributed to John W. Ayers,
Chicago, 1890–1913
Oak
H 30 in., W 31$^{11}/_{16}$ in., D 26$^{11}/_{16}$ in.
From the Francis W. Little house, Peoria,
Illinois; Frank Lloyd Wright, architect
Gift of Ruth L. and Walter Swardaenski
85.39

Frank Lloyd Wright designed this easy chair for a house that he was commissioned to build in Peoria, Illinois. His client, Francis W. Little, became Wright's close friend and financial supporter. A decade later, Wright built a second home for Little, overlooking Lake Minnetonka, in Deephaven, Minnesota. The Minneapolis Institute of Arts owns the hallway from the Deephaven residence (see no. 11).

This chair and its mate at the Nelson-Atkins Museum in Kansas City, Missouri, are nearly identical to chairs Wright had had made a year earlier for the William E. Martin house in Oak Park, Illinois (see no. 10). Although this chair looks stiff and uncomfortable, it can be adjusted to a reclining position and had cushions on the seat and back. The broad, straight planes of oak are ornamented only with simple wood moldings.

Unlike Gustav Stickley and other American proponents of the Arts and Crafts movement, many Prairie School architects, including Wright, Purcell, and Elmslie, welcomed machines and new technology. They felt that the repetitive work of cutting, planing, and sanding was best performed by machines, and much of Wright's furniture, with its flat planes and minimal ornamentation, was designed with machine manufacture in mind.

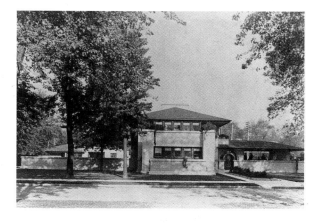

FRANCIS W. LITTLE HOUSE, PEORIA, ILLINOIS

RELEVANT TEXTS

Barter, "The Prairie School and Decorative Arts at the Art Institute of
 Chicago," pp. 132–33.

Bowman, *American Arts and Crafts*, p. 231.

Kaplan, *"The Art That Is Life,"* pp. 43, 59, 79, 92, 215, 391–95.

Volpe and Cathers, *Treasures of the American Arts and Crafts Movement*, pp. 49–56.

PROVENANCE

Francis and Mary Little

Mr. and Mrs. Robert Clark

Mr. and Mrs. Frank Foster

Mr. and Mrs. Charles Buehler

Ruth L. and Walter Swardaenski

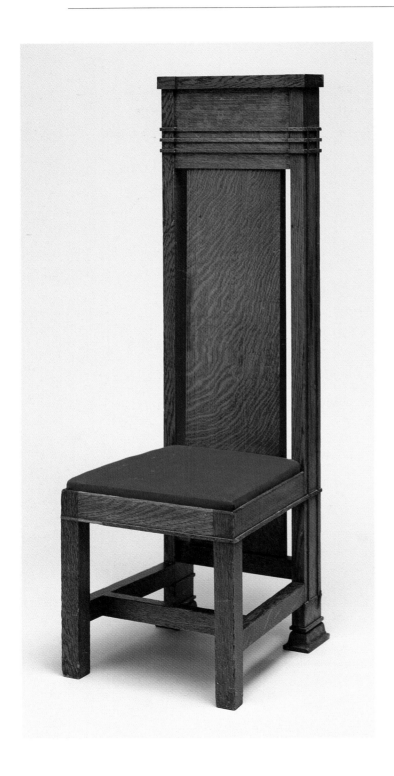

7.

SIDE CHAIR about 1903

DESIGNER: Frank Lloyd Wright
(American, 1867–1959)

MAKER: Attributed to John W. Ayers,
Chicago, 1890–1913

Oak

H 52 in., W 16¼ in., D 19½ in.

From the Francis W. Little house, Peoria, Illinois;
Frank Lloyd Wright, architect

Gift of Mr. and Mrs. Sheldon Sturgis 85.82

Wright's tall-back chairs are his trademark furniture of the Prairie School period. This chair from the Littles' Peoria house is unusual in having a solid, massive back of quartersawn oak, in sharp contrast to Wright's typical tall spindles. It might well have served as a hall chair originally, as hall chairs typically have solid wooden backs.

The Los Angeles County Museum of Art owns a similar but less elaborate side chair from the Littles' Peoria residence.

RELEVANT TEXTS

Bowman, *American Arts and Crafts*, pp. 95, 231.

Futagawa, *Frank Lloyd Wright Monograph*, vol. 2 (1902–6), pp. 16–25.

Kaplan, *"The Art That Is Life,"* pp. 394–95.

Volpe and Cathers, *Treasures of the American Arts and Crafts Movement*, pp. 49–56.

PROVENANCE

Francis and Mary Little

Timothy Hartneck, Peoria, Illinois (dealer)

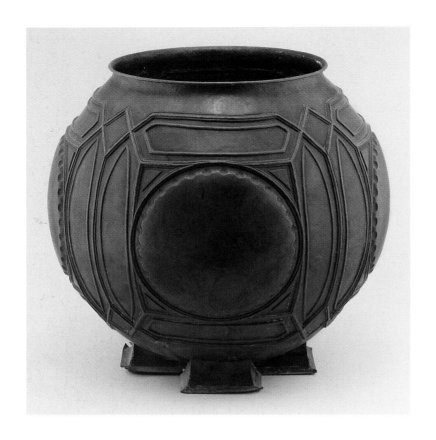

8.

URN about 1903

DESIGNER: Frank Lloyd Wright
(American, 1867–1959)

MAKER: James A. Miller and Brothers,
Chicago, 1889–at least 1903

Molded and hand–hammered sheet copper
H 18¾ in., D 19½ in.

The Modernism Collection, gift of
Norwest Bank Minnesota 98.276.3

Wright made two designs for urns, which he used in a number of his most important commissions. The urns were among Wright's favorite objects and fit in with his desire for an integrated environment that blended exterior and interior elements and brought nature indoors. Earlier photographs show the urns in the locations for which they were made, filled with ferns, evergreens, and bittersweet. Of the approximately eight known urns in Wright's two patterns, all probably dating between 1895 and 1903, none remains in its original architectural setting.

Constructed of separate molded, hand-hammered copper sections soldered together, the urns vary slightly in shape and dimensions. Each is raised on four flaring, rectangular feet. A patina built up with thin glazes of colored lacquer gives the appearance of age. The circle-in-a-square motif occurs in many Wright designs.

Other urns are in the Metropolitan Museum of Art in New York and the Chicago Historical Society.

RELEVANT TEXTS

Darling, *Chicago Metalsmiths*, pp. 70–71.

Duncan, *Modernism*, p. 44.

From Architecture to Object, p. 85.

Hanks, *The Decorative Designs of Frank Lloyd Wright*, pp. 20, 70–71.

EXHIBITIONS

Modernism at Norwest, Norwest Center, Minneapolis, 1989–90

Modernist Metalwork, 1900–1940, Norwest Center, Minneapolis, 1996–97

Forging a New Century: Modernist Metalwork, 1880–1940, Denver Art Museum, 1998–99

Reflections of a New Era: Modernist Metalwork, 1880–1940, The Minneapolis Institute of Arts, 2000–2001

PROVENANCE

Butterfield and Butterfield, Los Angeles and San Francisco

Norwest Corporation, Minneapolis

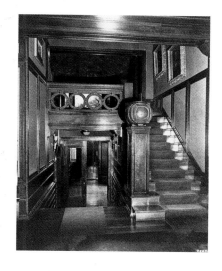

URN IN THE ENTRANCE HALL OF THE
E. C. WALLER HOUSE, RIVER FOREST,
ILLINOIS, REMODELED BY FRANK LLOYD
WRIGHT IN 1899

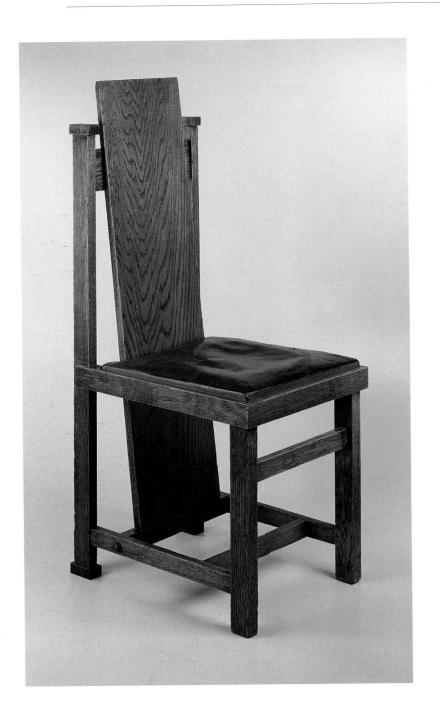

9.

SIDE CHAIR about 1904

DESIGNER: Frank Lloyd Wright
(American, 1867–1959)

Oak with leather-covered slip-seat; replacement block feet

H 39¼ in., W 15 in., D 19¼ in.

The Modernism Collection, gift of
Norwest Bank Minnesota 98.276.4

This chair design was for the Hillside Home School, a private school run by Wright's aunts, Nell and Jane Lloyd Jones. The original Hillside Home School was built in 1887 in Spring Green, Wisconsin, on land that belonged to Wright's family—the site, later, of Wright's home, Taliesin, and of the first Taliesin Fellowship. Wright designed a larger, more complex school building in 1901 and another in 1903. Side chairs of this type were made for the 1903 Hillside Home School. A slightly modified version was placed in several other Wright interiors, including Wright's own home and studio in Oak Park, Illinois; the Larkin Administration Building in Buffalo, New York; and Unity Temple in Oak

Park. The simple square frame and angled backrest recall an earlier modern chair, of 1885, by the English designer E. W. Godwin. Wright's simplified design was later developed by the Dutch architect Gerrit Rietveld in the famous modernist Red-Blue chair (1917–18). Examples of both chairs are in the collection of The Minneapolis Institute of Arts.

The Los Angeles County Museum of Art owns a pair of chairs of the same design from Wright's Oak Park home and studio. Others can be found in the Virginia Museum of Fine Arts in Richmond, the Carnegie Museum of Art in Pittsburgh, and the Metropolitan Museum of Art in New York.

RELEVANT TEXTS

Barter, *American Arts at the Art Institute of Chicago*, pp. 312–13.

Barter, "The Prairie School and Decorative Arts at the Art Institute of Chicago," pp. 128–29.

Bowman, *American Arts and Crafts*, pp. 92–93.

Darling, *Chicago Furniture*, p. 265.

Duncan, *Modernism*, pp. 48–49.

Hanks, *Frank Lloyd Wright*, pp. 50–51.

Spencer, *The Prairie School Tradition*, p. 57.

Volpe and Cathers, *Treasures of the American Arts and Crafts Movement*, pp. 53–54.

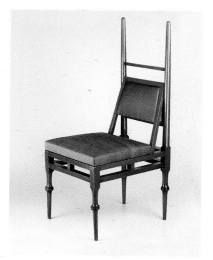

EXHIBITIONS

Milestones of Modernism, 1880–1940: Selections from the Norwest Collection,
 The Minneapolis Institute of Arts, 1999

PROVENANCE

Domino's Center for Architecture and Design, Ann Arbor, Michigan

Norwest Corporation, Minneapolis

TOP TO BOTTOM

RIETVELD'S "RED-BLUE" CHAIR (THE
MODERNISM COLLECTION, GIFT OF
NORWEST BANK MINNESOTA)

GODWIN'S SIDE CHAIR (THE ULRICH
ACQUISITION FUND FOR MODERN DESIGN)

91

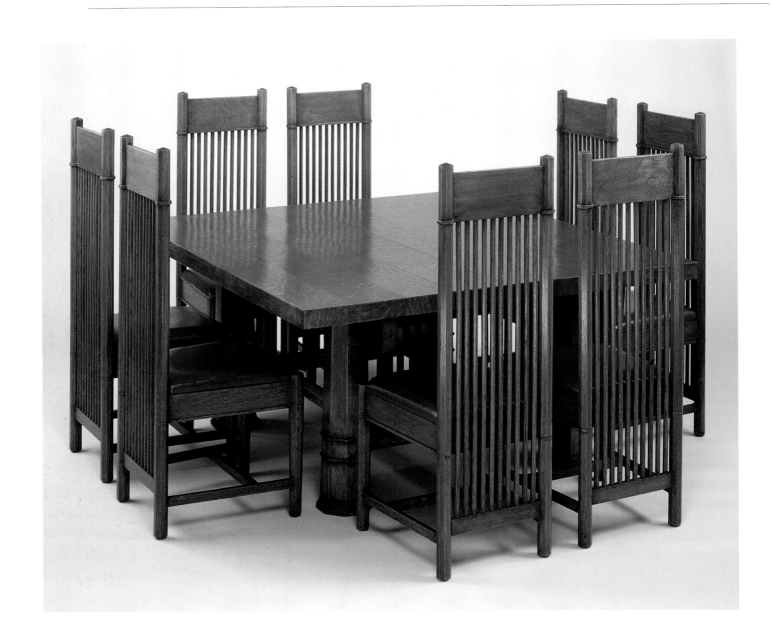

10.

DINING TABLE AND EIGHT CHAIRS 1904

DESIGNER: Frank Lloyd Wright (American, 1867–1959)

MAKER: Matthews Brothers Furniture Company, Milwaukee, Wisconsin, 1857–1937

Oak, metal, leather

Table: H 28¾ in., W 54¾ in., D 60³⁄₁₆ in.; two leaves (each): L 54½ in., W 15 in.; eight chairs (each): H 37¼ in., W 17⅛ in., D 18 in.

From the George Barton house of the Darwin D. Martin complex in Buffalo, New York; Frank Lloyd Wright, architect

Gift of the Regis Corporation 99.29.1–9

Frank Lloyd Wright designed this imposing dining room set for the house of Mr. and Mrs. George Barton in Buffalo, New York. Delta Barton was the sister of Darwin D. and William E. Martin, two of Wright's most important commercial and residential clients. The Martins awarded Wright nine commissions in Chicago and Buffalo, including the Larkin Administration Building, home of a mail-order business founded by John Larkin and Elbert Hubbard, who went on to lead the Arts and Crafts group called the Roycrofters.

▼

Wright designed the Barton house and its furnishings to complement the grander house of Darwin D. Martin. The dining chairs resemble other early Wright chairs in having tall backs decorated with narrow vertical spindles connected to a broad crest rail. Grouped around the table, the tall backs create a "room within a room." The unusual octagonal motif of the spindles continues in the table's base and legs.

Soon after the Bartons' house was completed, Mrs. Barton gave her dining set to her brother William E. Martin, who commissioned Wright to design a strikingly similar table and chairs for the breakfast room of his Chicago house. These two suites are the only furniture designs in which Wright used octagonal elements.

RELEVANT TEXTS

Counterpoint: Two Centuries of American Masters (New York: Hirschl and Adler Galleries, 1990), pp. 108–9.

The Craftsman Table, no. 40.

Frank Lloyd Wright Retrospective Exhibition, pp. 94, 264, 272.

From Architecture to Object, pp. 88–89.

Futagawa, *Frank Lloyd Wright Monograph*, vol. 2 (1902–6), pp. 62–63.

Hanks, *The Decorative Designs of Frank Lloyd Wright*, pp. 42, 91.

In Pursuit of Order, pp. 8–9, 14–15.

EXHIBITIONS

In Pursuit of Order: Frank Lloyd Wright from 1897 to 1915, Struve Gallery, Chicago, 1988–89

From Architecture to Object: Masterworks of the American Arts and Crafts Movement, Hirschl and Adler Galleries, New York, 1989; Struve Gallery, Chicago, 1989–90

Counterpoint: Two Centuries of American Masters, Hirschl and Adler Galleries, New York, 1990

Frank Lloyd Wright Retrospective Exhibition, Sezon Museum of Art, Tokyo; National Museum of Modern Art, Kyoto; Yokohama Museum of Art; and Kitakyusha Municipal Museum of Art, 1991

The Craftsman Table, Hirschl and Adler Galleries, New York, 1992

The Art of Frank Lloyd Wright: Photography, Architectural Design, and Furniture (one chair), Barry Friedman Limited, New York, in association with Kelmscott Gallery, Chicago, 1994

PROVENANCE

George and Delta Martin Barton

William E. Martin, and by descent until 1987

Christie's, New York

Hirschl and Adler Galleries, Inc., New York (dealer)

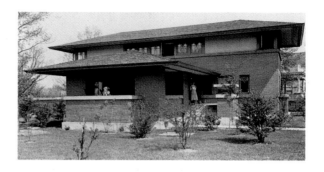

GEORGE BARTON HOUSE, BUFFALO, NEW YORK

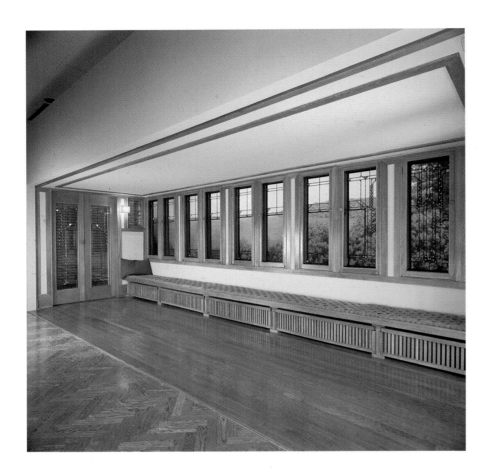

11.

HALLWAY 1912–14

ARCHITECT: Frank Lloyd Wright (American, 1867–1959)

MAKER: Temple Art Glass Company, Chicago, 1903-30s (glass)

Oak, pine, glass, copper-coated zinc caming, porcelain, brass hardware, metal screens, cotton canvas upholstery, fabric-covered shades

L 18 ft., W 16 ft.

From the Francis W. Little house, Deephaven, Minnesota (demolished 1972)

The David Draper Dayton Fund

72.11

In 1907 Francis and Mary Little of Peoria, Illinois, purchased land in Deephaven, Minnesota, overlooking Robinson's Bay on Lake Minnetonka, about ten miles west of Minneapolis. Mr. Little, a lawyer and owner of a utilities company, was in poor health, and in an effort to find a better climate, the Littles and their only child, Eleanor, moved to a house in the Kenwood area of Minneapolis the following year. They commissioned Frank Lloyd Wright, the architect of their home in Peoria (see nos. 6 and 7), to design a summer residence for them on their lakeshore property, and initial plans were drawn in 1908. The construction of the house, however, was not completed until 1914, as Wright left for Europe in 1909, returned in 1911, and then spent part of 1913 in Japan.

Although several letters from Mr. Little to Wright indicate his frustration with the delay, the Littles had a close relationship with Wright and preferred to wait for him rather than choose another architect. In the meantime, they spent their summers at the lake in a cottage that Mr. Little had designed in Wright's style.

The home that Wright designed for the Littles was one of his last great Prairie School houses. Characteristically long and low, with a hipped roof, the building hugged two gentle hills overlooking the lake. The plan consisted of two offset rectangles, joined at the corner to form a single 250-foot axis parallel to the lakeshore. Windows spanned the entire lakeside elevation, giving the Littles full advantage of the scenic view. There was much discussion between Wright, who drew elaborate designs for the windows, and Mr. Little, who did not want an intricate pattern to obscure his view of the lake. A compromise resulted. In the many large expanses of glass throughout the house, a central area of plain glass is "framed" with a border that includes white and red squares and triangles. In this hallway, the "framed" area terminates in a more complex design on the three right windows. The most spacious and elegant room was the living and music room, planned especially for Mrs. Little, an accomplished pianist who had studied under Franz Liszt in Cologne and planned to host recitals at the house. The sprawling, wood-trimmed brick house was approached by thirty-six steps, arranged in three units, leading up to the grand entrance.

▼

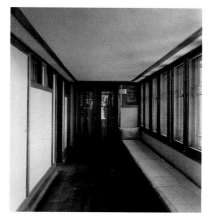

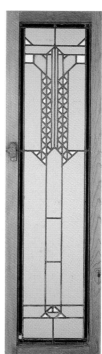

TOP TO BOTTOM

HALLWAY IN
THE LITTLE
HOUSE,
BEFORE
REMOVAL

DETAIL OF
HALLWAY
WINDOW

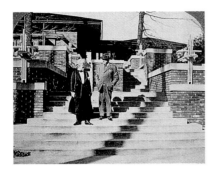

FRANCIS AND MARY LITTLE
ON THE STEPS OF THEIR HOUSE

Mr. Little died in 1923. Mrs. Little moved into the cottage and gave the summer home to Eleanor and her husband, Raymond Stevenson. Around 1951 the Stevensons sold their Minneapolis home and winterized the summer house so they could live in it year round. By the late 1960s, however, the Stevensons had grown weary of the challenges of living in a Wright-designed house. The large size of the house, rising property taxes, built-in furnishings that could not be easily changed, and many uninvited visitors became too much for them. Not wishing to move or tear down their house, and yet wanting a smaller house, the Stevensons were in a difficult situation because city zoning ordinances would not permit two houses on the same lot. They made every effort to find a purchaser, but no local buyer or institution could be found to save the house in situ. A group of Wright enthusiasts contacted officials at the Metropolitan Museum of Art in New York, to see if the museum might be able to purchase it for partial reinstallation.

The Metropolitan Museum bought only the house in 1972, allowing the Stevensons to retain the property. Portions of the interior were carefully dismantled piece by piece for future installation in the Metropolitan and for sale to other institutions. That same year the Metropolitan sold the library to the Allentown Art Museum in Allentown, Pennsylvania, and a hallway to The Minneapolis Institute of Arts. In 1982, the Metropolitan installed the large living and music room in its American Wing. In 1986 the master bedroom was purchased for the Domino's Pizza Collection (later part of Domino's Center for Architecture and Design).

At the Institute, the hallway joined works from Francis Little's art collection. In 1917 Little, a trustee of the Institute, had given Hiroshige's Tokaido Road series from his collection of Japanese prints, most of which (including this gift) he had acquired from Frank Lloyd Wright as collateral for a loan that Wright never repaid.

The hallway, which led to the master bedroom, has been installed in The Minneapolis Institute of Arts without its fourth wall (which contained closets and a door to Eleanor's room), allowing a broader view of the windows.

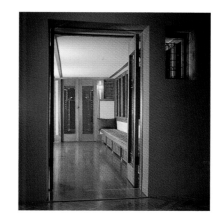

RELEVANT TEXTS

Futagawa, *Frank Lloyd Wright Monograph*, vol. 3 (1907–13), pp. 204–17.

Heckscher, "Collecting Period Rooms," pp. 207–17.

Heckscher and Miller, *An Architect and His Client.*

Made in America: Ten Centuries of American Art (New York: Hudson Hills Press, 1995), p. 125.

Prairie School Architecture in Minnesota, Iowa, Wisconsin, p. 89.

Spencer, *The Prairie School Tradition*, p. 84.

EXHIBITIONS

Prairie School Architecture in Minnesota, Iowa, and Wisconsin, Minnesota Museum of Art, St. Paul, 1982

Minnesota 1900: Art and Life on the Upper Mississippi, 1890–1915, The Minneapolis Institute of Arts, 1994

Made in America: Ten Centuries of American Art (windows only), The Minneapolis Institute of Arts, 1995; Saint Louis Art Museum, 1995; Toledo Museum of Art, 1995–96; Nelson-Atkins Museum of Art, Kansas City, 1996; Carnegie Museum of Art, Pittsburgh, 1996

PROVENANCE

Francis and Mary Little

Raymond and Eleanor Stevenson

Metropolitan Museum of Art

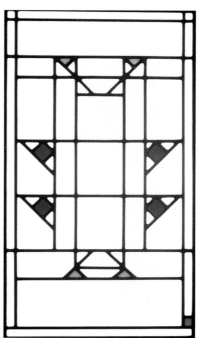

TOP TO BOTTOM

HALLWAY VIEWED THROUGH DOORS

HALLWAY WINDOW DETAIL

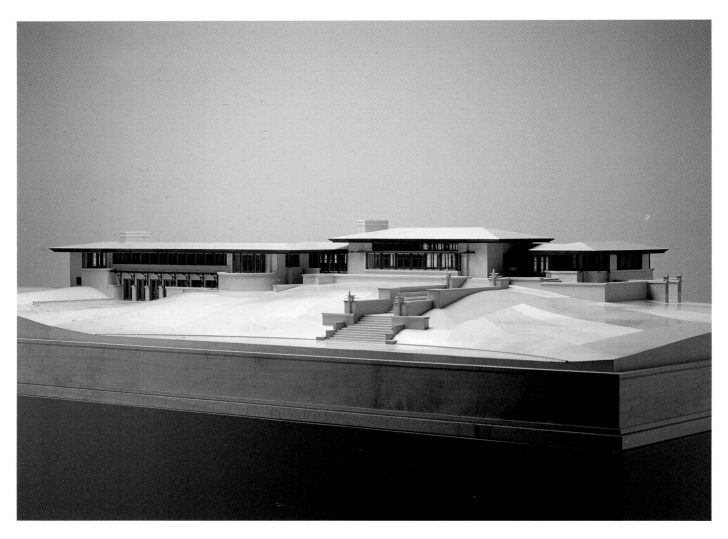

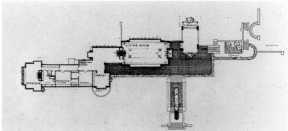

PLAN OF THE LITTLE HOUSE

12.

MODEL OF THE FRANCIS W. LITTLE HOUSE (1912–14) 1998–99

ARCHITECT: Frank Lloyd Wright (American, 1867–1959)

MAKER: David Swanson, Construct Studios, St. Paul, Minnesota

Maple, maple veneer, Plexiglas, nylon screen

H 8½ in., W 72¹¹⁄₁₆ in., D 41¹³⁄₁₆ in.

Scale: ¼ in. to 1 ft.

Gift of Kenneth and Judy Dayton 2000.22

This model illustrates in three dimensions both the complexity of Wright's design and its complete engagement with the site. (Wright always favored building *into* a hill rather than on the top.) The main approach to the house was on the inland side. The Institute's hallway was on the lake side, at the opposite end from the large living and music room pavilion. An adjoining hallway with small square clerestory windows connected the Institute's hallway to the master bedroom on the far right end of the house.

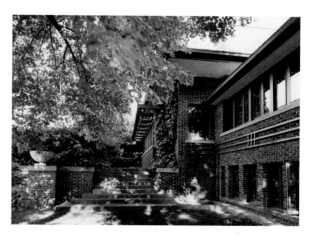

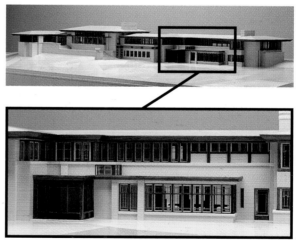

TOP TO BOTTOM

LITTLE HOUSE, LAKESIDE STAIRS AND TERRACE

MODEL, LAKESIDE VIEW

MODEL, LAKESIDE VIEW, SHOWING THE HALLWAY WINDOWS ON THE SECOND LEVEL (CENTER)

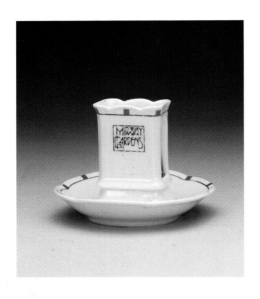

13.

MATCH HOLDER 1914

DESIGNER: Frank Lloyd Wright (American, 1867–1959)

MAKER: Bauscher, Weiden, Germany, 1881–present

Glazed porcelain

H 3½ in., D 4½ in.

Marks: "New York, Chicago, Bauscher, Weiden (Germany), 1914"

From the Midway Gardens, Chicago (demolished 1929);
 Frank Lloyd Wright, architect

The Modernism Collection, gift of Norwest Bank Minnesota
 98.276.5.1

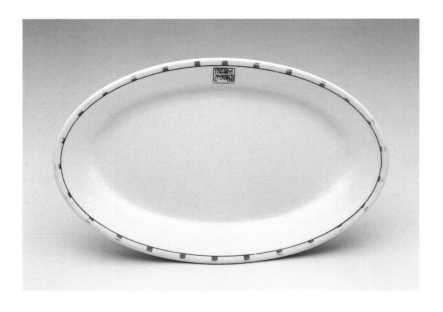

14.

OVAL PLATTER 1914

DESIGNER: Frank Lloyd Wright
 (American, 1867–1959)

MAKER: Bauscher, Weiden, Germany,
 1881–present

Glazed porcelain

H 6¼ in., W 9¾ in.

Marks: "New York, Chicago, Bauscher,
 Weiden (Germany), 1914"; impressed in
 an oval, "Weiden, Germany"

From the Midway Gardens, Chicago
 (demolished 1929); Frank Lloyd Wright,
 architect

The Modernism Collection, gift of
 Norwest Bank Minnesota 98.276.5.3

15.

BEER STEIN 1914

DESIGNER: Frank Lloyd Wright (American, 1867–1959)

Glass, pewter

H 7 in., Diam 3½ in.

From the Midway Gardens, Chicago (demolished 1929);
Frank Lloyd Wright, architect

The Modernism Collection, gift of Norwest Bank Minnesota
98.276.5.2

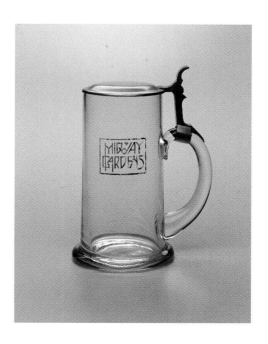

Midway Gardens was an elaborate, block-long entertainment complex designed by Frank Lloyd Wright in 1914. Modeled on German beer gardens, it had an interior court that served as a summer gathering place for dining, dancing, and concerts. Wright incorporated decoration into this dramatic structure through his innovative use of patterned concrete block on the exterior and by placing sculptures by Alfonso Iannelli and Richard Bock throughout.

▼

The Institute's match holder, platter, and beer stein were among the few objects to survive the destruction of the garden and most of its Wright-designed furnishings in 1929. This match holder and platter were made in Germany by the Bauscher factory. The same pattern was also produced by Shenango China of New Castle, Pennsylvania, probably because importing replacements was difficult after the First World War broke out.

The decoration on the ceramics—a single row of red squares aligned along the rim—recalls the geometric elements in the work of various progressive European architect-designers Wright saw on his visit to Europe in 1909–10. With the beer stein, Wright rendered a familiar German form in a progressive way by using modernist lettering on the glass body.

RELEVANT TEXTS

Brooks, *The Prairie School*, pp. 87, 201, 235.

Duncan, *Modernism*, p. 49.

Futagawa, *Frank Lloyd Wright Monograph*, vol. 3 (1907–13), pp. 238–65.

Hanks, *Frank Lloyd Wright*, pp. 86–87.

Spencer, *The Prairie School Tradition*, p. 85.

EXHIBITIONS

Milestones of Modernism, 1880–1940: Selections from the Norwest Collection
 (ceramics only), The Minneapolis Institute of Arts, 1999

PROVENANCE

(Platter)

Domino's Center for Architecture and Design, Ann Arbor, Michigan

Norwest Corporation, Minneapolis

(Match holder; beer stein)

Kelmscott Galleries, Chicago (dealer)

Norwest Corporation, Minneapolis

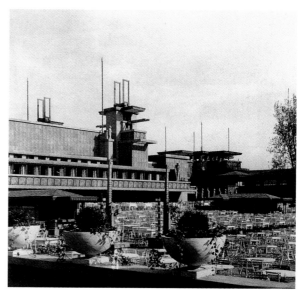

TOP TO BOTTOM

DINING ROOM AT MIDWAY GARDENS

MIDWAY GARDENS, CHICAGO, ABOUT 1913-14

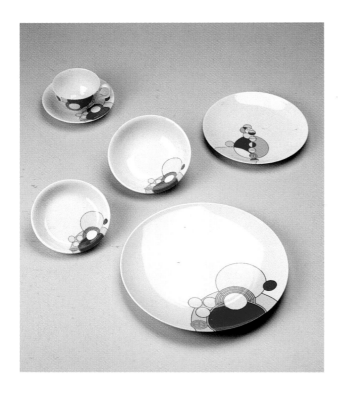

16.

SET OF TABLEWARE designed 1922

DESIGNER: Frank Lloyd Wright
(American, 1867–1959)

MAKER: Noritake, Noritake, Japan, 1904–present

Six place settings of seven pieces; this set manufactured
1962–66

Porcelain

Cup: Diam 3½ in.; saucer: Diam 5⁵⁄₁₆ in.; dinner plate:
Diam 10½ in.; bread plate: Diam 6¼ in.; salad plate:
Diam 7⁹⁄₁₆ in.; salad bowl: Diam 5¾ in.; dessert bowl:
Diam 5⅛ in.

Original design for the Imperial Hotel, Tokyo
(demolished 1968); Frank Lloyd Wright, architect

Gift of Mr. and Mrs. Roger Kennedy 79.26.1–42

The largest commission of Frank Lloyd Wright's long career was the Imperial Hotel and Annex in Tokyo. Wright worked on the project on and off from 1916 to 1922. It was one of his most lavishly decorated structures, intended for state functions and well-to-do tourists. Built primarily of native soft lava known as *oya* stone, the hotel blended respectfully and subtly into its Japanese surroundings. It became famous as one of the few buildings in Tokyo to survive the great earthquake of 1923. The U.S. Army occupied and altered the Imperial Hotel after the Second World War, and Wright was offered an opportunity to remodel it at that time but refused. In the 1960s, as Tokyo land values rose, tearing down the hotel became more economical than renovating it, and in 1968 it was demolished.

Wright created an entire decorative scheme for the Imperial Hotel, including furniture, carpets, a silver coffee service, and this dinner service design for the informal Cabaret Room. The first dinner service design was developed in 1922 and used until 1933. Changes were then made several times

over the years in the position and size of the circles. The Institute's place settings—never actually used in the hotel—were manufactured sometime between 1962 and 1966. Although the pieces are conventional in form, the decoration is bold and colorful, featuring blue, red, yellow, and green circles, with black or gold outlines, placed asymmetrically on a white background. The circles recall the well-known motifs of the windows in Wright's Avery Coonley playhouse (1912) in Riverside, Illinois.

Other place settings from the same service (originally bought by Mr. and Mrs. Roger Kennedy for their own use) are in the collections of the Metropolitan Museum of Art, New York; the Smithsonian Institution, Washington, D.C.; and the Cooper-Hewitt, National Design Museum, New York.

RELEVANT TEXTS

Futagawa, *Frank Lloyd Monograph*, vol. 4 (1914–23), pp. 18–61.

Hanks, *The Decorative Designs of Frank Lloyd Wright*, pp. 134–35, pl. 13.

Hanks, *Frank Lloyd Wright*, p. 95.

James, *Frank Lloyd Wright's Imperial Hotel.*

Spencer, *The Prairie School Tradition*, pp. 86–87.

EXHIBITIONS

The Decorative Arts of Frank Lloyd Wright, Renwick Gallery, Washington,
 D.C., 1978

PROVENANCE

Mr. and Mrs. Roger Kennedy

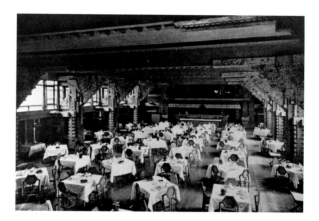

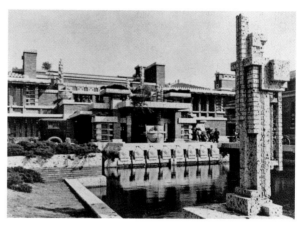

TOP TO BOTTOM

MAIN DINING ROOM OF THE IMPERIAL HOTEL

IMPERIAL HOTEL, TOKYO

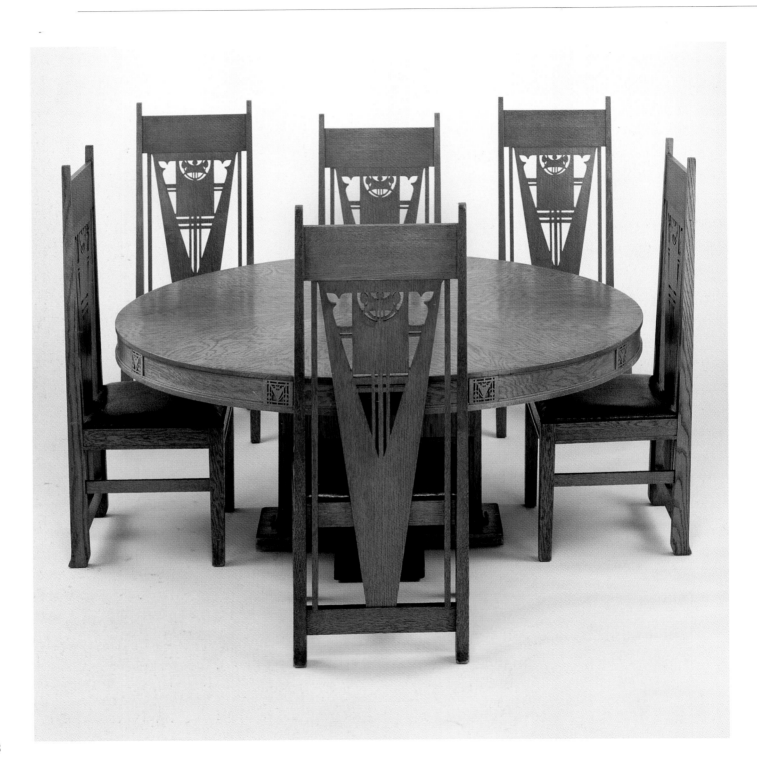

17.

DINING TABLE AND EIGHT CHAIRS 1910

DESIGNER: George Grant Elmslie (American, b. Scotland, 1869–1952)

Made in Chicago

Oak, oak veneer, synthetic upholstery, jute webbing

Table: H 29⁹⁄₁₆ in., Diam 66 in.; eight chairs (each): H 50³⁄₁₆ in., W 20⁵⁄₁₆ in.,
 D 18½ in. (six are shown)

From the T. B. Keith house, Eau Claire, Wisconsin (demolished about 1960)

Gift of T. Gordon and Gladys P. Keith 99.62.1–9

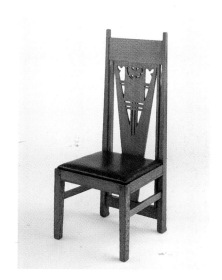

In 1909, the architects Purcell and Feick received a commission from J. D. R. Steven, a Wisconsin businessman, for a house in the older section of Eau Claire. It was one of several Eau Claire commissions Purcell's firm carried out between 1908 and 1915. At the time Steven's house was being planned, a neighbor, Mrs. T. B. Keith, wished to modernize her nineteenth-century house and invited the architects over for a visit. The following year, George Elmslie, who had just left Louis Sullivan's office and joined Purcell, designed a dining room suite that undoubtedly gave the Keith home a contemporary feel.

▼

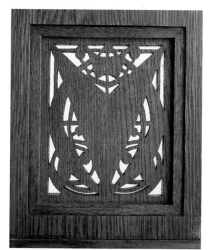

TOP TO BOTTOM

DINING CHAIR FROM THE T. B.
KEITH HOUSE

DETAIL OF SAWED-WOOD TABLE DESIGN

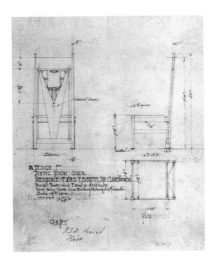

The elaborate seat backs, table legs, and table frieze demonstrate Elmslie's facility at translating stylized organic ornament into sawed wood. Sawed-wood decoration was also used to great effect in houses designed by the firm, including the Purcell-Cutts house, now owned by The Minneapolis Institute of Arts. Elmslie produced similar dining room suites (some with square tables) for other clients, including Harold C. and Josephine Crane Bradley of Madison, Wisconsin, and E. L. Powers of Minneapolis. And he had one made as a present for his wife, Bonnie Hunter Elmslie. The Keiths' suite, however, is the only one known to survive intact, having remained in the Keith family until its donation to The Minneapolis Institute of Arts.

One chair from the Elmslie suite and two from the Bradley suite are known to exist, and a chair probably from the Keith suite is in the Art Institute of Chicago.

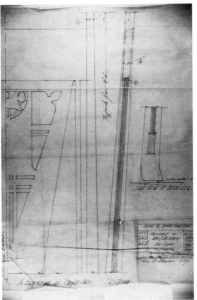

TOP AND BOTTOM

CHAIR DESIGNS

RELEVANT TEXTS

Barter, *American Arts at the Art Institute of Chicago*, pp. 307–9.

Barter, "The Prairie School and Decorative Arts at the Art Institute of Chicago,"
 pp. 118–21.

Kaplan, *"The Art That Is Life,"* pp. 204–5.

Legler, *Prairie Style*, pp. 84–87.

Phillips et al., *High Styles*, pp. 32–35.

Spencer, *The Prairie School Tradition*, p. 42.

EXHIBITIONS

Prairie School Architecture in Minnesota, Iowa, and Wisconsin (two chairs),
 Minnesota Museum of Art, St. Paul, 1982

Recent Accessions, The Minneapolis Institute of Arts, 1999

PROVENANCE

Mr. and Mrs. T. B. Keith

T. Gordon and Gladys P. Keith

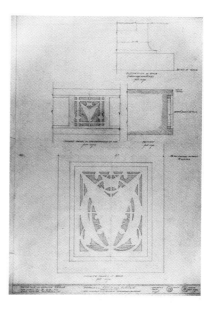

TABLE DESIGN DETAILS

18.

SET OF SIX ART-GLASS PANELS
FOR A BAY WINDOW 1909

DESIGNER: William Gray Purcell
(American, 1880–1965)

MAKER: Mosaic Art Shops (E. L. Sharretts),
Minneapolis, 1912–30

Glass, zinc caming

Each: H 60 in., W 24 in. (one is shown)

From the George W. Stricker house, Minneapolis

The Ethel Morrison Van Derlip Fund 94.28.1–6

These art-glass panels were made for a bay window for a sun-room addition to George W. Stricker's house in the Kenwood neighborhood of Minneapolis. The designs reflect Purcell's fascination with modern technology. Much later, in 1939, Purcell wrote about his inspiration for these windows. In 1909 at the Orpheum vaudeville show he had seen a "moving picture" called "The June Bug," featuring the aviator Glenn Curtiss flying his biplane. "To partners who were endeavoring in their work to relate Architecture and the Machine, such a sight gave serious pause. I made a record of my feelings by putting a 'June Bug' biplane against some big piled-up clouds in the leaded glass transoms of the new Stricker dining room bay window."

The Strickers, happy with their new sunroom, asked Purcell and Elmslie to design a new house for them in 1910. But Mrs. Stricker's specifications exceeded what Mr. Stricker felt he could spend, and the project remained unbuilt. In 1915 Purcell and Elmslie remodeled the Stricker house again, this time making alterations to the dining room, porch, second-floor bedrooms, and sleeping porch.

RELEVANT TEXTS

Conforti, *Minnesota 1900*, pp. 281–82.

EXHIBITIONS

Minnesota 1900: Art and Life on the Upper Mississippi, 1890–1915,
 The Minneapolis Institute of Arts, 1994

PROVENANCE

Mr. and Mrs. George W. Stricker

James E. Johnson

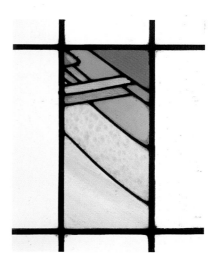

TOP TO BOTTOM

DETAIL, BIPLANE MOTIF

PURCELL'S WATERCOLOR SKETCH OF
BIPLANE MOTIF

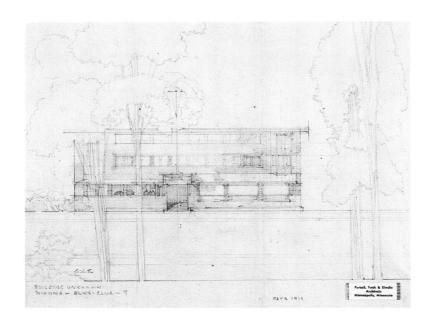

19.

FRONT ELEVATION, POSSIBLY FOR ELKS CLUB, WINONA 1910

ARCHITECTS: Purcell, Feick and Elmslie, Minneapolis

Graphite on paper

H 7⅜ in., W 10⅝ in.

Inscriptions: "G.G.E./Building Unknown/ Winona-Elks-Club?" in pencil, lower left corner; "Date 1911" in pencil, lower center; "Purcell, Feick & Elmslie/ Architects/Minneapolis, Minnesota," on label, lower right corner

Gift of Roger G. Kennedy 98.256.1

In 1910, Purcell's firm entered an architectural competition for the Elks Club of Winona, a commission they did not win. Purcell later wrote that he realized soon after they submitted drawings that the clients had already chosen their architect and were using his and other entries for comparison. Purcell probably dated the sketch in later years, hence the discrepancy.

RELEVANT TEXTS

Conforti, *Minnesota 1900*, p. 292.

PROVENANCE

Roger G. Kennedy

20.

TWO ARMCHAIRS about
1912–13

DESIGNERS: William Gray Purcell
(American, 1880–1965) and
George Grant Elmslie (American,
b. Scotland, 1869–1952)

Oak, leather

From the Merchants National Bank of
Winona, Winona, Minnesota; Purcell,
Feick and Elmslie, architects

Each: H 36½ in., W 24⅜ in., D 26 in.
(one is shown)

Driscoll Arts Accession Fund 93.1, 93.54

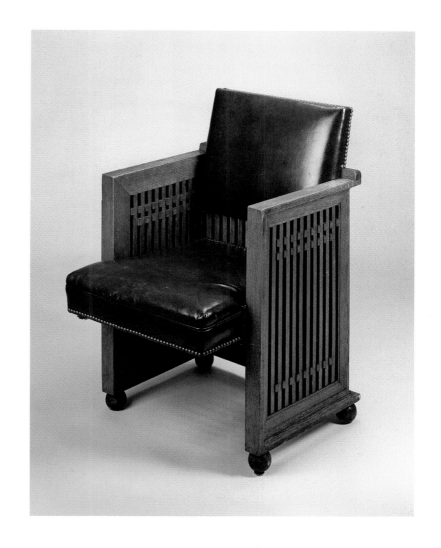

Taking their lead from Louis Sullivan's small-town bank buildings, the most notable being the National Farmers' Bank in Owatonna (1907–8), Purcell and Elmslie designed a number of midwestern banks. These square brick buildings with their art-glass windows embodied the qualities of solidity and stability important to bankers and their customers. Often local agriculture was represented on the bank's exterior by stylized grain motifs executed in terra-cotta, while murals of farm scenes adorned the inside walls. Purcell and Elmslie's most elaborate bank was the Merchants Bank of Winona, Minnesota, still in use as a bank today.

▼

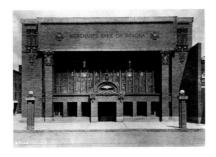

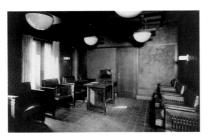

TOP TO BOTTOM

MERCHANTS NATIONAL BANK
OF WINONA, WINONA, MINNESOTA

WAITING ROOM, MERCHANTS
NATIONAL BANK

After his wife, Bonnie Hunter Elmslie, died in 1912, Elmslie returned to Chicago, where he lived with his sisters and ran the firm's branch office. Previously the Chicago "office" had consisted of the phone number of Elmslie's sisters. Purcell and Elmslie continued to work together closely on the firm's projects, sending letters and telegrams regularly. Their collaboration is illustrated in notes and drawings respecting the design of these chairs. In June 1913, Purcell wrote on a sketch to Elmslie, "GG, you *have* to do a little thinking on the chairs—they are *not* comfortable and must be made so." Elmslie replied to Purcell on the sketch and in an accompanying letter: "The Winona chairs are the toughest kind of a problem to get comfort and appearance with the present basis. I have been trying all kinds of variants from your sketches and really feel that a cushion panel back rest is the best of them all, only I would make it as wide as we possibly can." Apparently Purcell agreed, for the actual chairs closely follow the sketches and Elmslie's description. Concern for the needs and comfort of their clients is a recurring theme in Purcell and Elmslie's work.

Twelve chairs of this design were made for the bank directors' boardroom. (Similar chairs were placed in a waiting room.) Their cubelike shape echoes that of the bank building. The vertical spindle "screens" forming the sides probably influenced Purcell and Elmslie's designs of armchairs and decorative interior elements for the Edna S. Purcell residence (now the Purcell-Cutts house), in Minneapolis.

Two of the chairs are still owned by the Merchants National Bank; some are in the collection of the Winona County Historical Society; and another is in the Art Institute of Chicago.

RELEVANT TEXTS

Barter, "The Prairie School and Decorative Arts at the
Art Institute of Chicago," pp. 121–22, 124.

Brooks, *The Prairie School*, pp. 201–5.

Conforti, *Minnesota 1900*, pp. 238, 288.

From Architecture to Object, pp. 72-73.

Kaplan, *"The Art That Is Life,"* pp. 203–4.

Volpe and Cathers, *Treasures of the American Arts and Crafts Movement*, pp. 59–61.

EXHIBITIONS

Minnesota 1900: Art and Life on the Upper Mississippi, 1890–1915,
The Minneapolis Institute of Arts, 1994

PROVENANCE

(93.1)

Merchants National Bank of Winona, Winona, Minnesota

John Leaf

(93.54)

Merchants National Bank of Winona, Winona, Minnesota

Country Comfort Antiques, Winona, Minnesota (dealer)

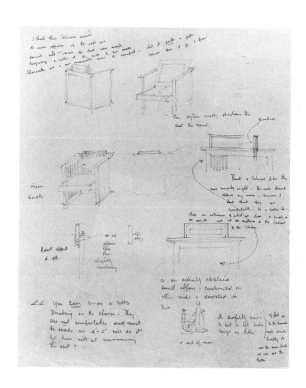

PURCELL AND ELMSLIE'S IDEAS FOR MERCHANTS
NATIONAL BANK CHAIRS

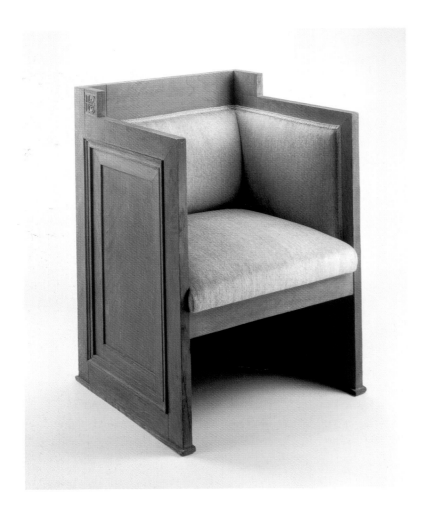

21.

ARMCHAIR 1912

DESIGNERS: William Gray Purcell
(American, 1880–1965) and
George Grant Elmslie (American,
b. Scotland, 1869–1952)

Oak with replacement cloth upholstery

H 35⅞ in., W 25⅜ in., D 23⅛ in.

For the Henry B. Babson house, Riverside,
Illinois (demolished 1960); Louis Sullivan,
architect

Gift of David and Patricia Gebhard

98.235.3

In 1909 Louis Sullivan and George Grant Elmslie designed the Henry Babson residence, with Elmslie working extensively on all aspects of the house (see no. 4). When Babson wanted alterations around 1912, he entrusted them to Elmslie and his new partner, William Purcell. The two architects designed furniture for the house, including a tall-case clock and andirons, now at the Art Institute of Chicago, and this box chair with small B's carved on the sides. In a contemporary photograph, the chair is shown across from a nineteenth-century Chinese chair of Babson's which might well have inspired it, just as Asian design influenced the furniture and architecture of Charles and Henry Greene's California bungalows.

The firm was otherwise reluctant to change what Purcell later called "this magnificent Louis Sullivan house." Babson's plans included enclosing the impressive second-floor arcade, which Purcell and Elmslie did around 1912. One room Babson wanted to add, a "grand salon," was drawn up by Elmslie in 1918–19, but as Elmslie did not want to see it built, he stalled, and in 1923 Babson had other architects build the addition. According to Purcell, it was "furnished with period furniture and Renaissance tapestries," a treatment he considered incompatible with the progressive Sullivan house.

Babson retained Purcell and Elmslie for other projects during this period. He owned one of the firms selling Edison phonograph machines, and in 1912 Purcell and Elmslie made alterations on his Edison shop in Chicago. They were very proud of their wholly original complex of 1915–16, comprising five service buildings near the Babson house. The Babson house was torn down in 1960.

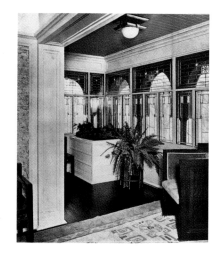

BABSON HOUSE BALCONY AFTER
REMODELING BY PURCELL AND ELMSLIE,
ARMCHAIR AT RIGHT

RELEVANT TEXTS

Brooks, *The Prairie School*, pp. 303–5.

From Architecture to Object, p. 71.

Phillips et al., *High Styles*, pp. 32–35.

EXHIBITIONS

High Styles: Twentieth-Century American Design, Whitney Museum
 of American Art, New York, 1986

PROVENANCE

Henry B. Babson

David and Patricia Gebhard

22.

CEILING LIGHT FIXTURE 1913
DESIGNERS: William Gray Purcell
(American, 1880–1965) and George Grant Elmslie
(American, b. Scotland, 1869–1952)
MAKER: Mosaic Art Shops (E. L. Sharretts),
Minneapolis, 1912–30
Glass, zinc caming
Diam 20 in.
From the Edna S. Purcell house (now the
Purcell-Cutts house), Minneapolis;
Purcell and Elmslie, architects
Bequest of Anson Cutts, Jr. 90.92.84

This light fixture was designed for the back porch of Purcell's own house (now the Purcell-Cutts house). It hung parallel to the ceiling, below a recessed light well that held a single bulb. An identical fixture is still in place in the entrance hall of the house; a reproduction has been made for the porch. The round panel contains the V-shaped motifs Elmslie included in the art-glass windows, doors, and bookcase doors throughout the Purcell-Cutts house.

PROVENANCE

William Gray Purcell and Edna S. Purcell

Anson Cutts, Sr., and Edna Cutts

Anson Cutts, Jr.

23.

MODEL OF THE EDNA S. PURCELL HOUSE (NOW THE PURCELL-CUTTS HOUSE) (1913)

1997

ARCHITECTS: Purcell and Elmslie, Minneapolis

MAKER: David Swanson, Construct Studios, St. Paul, Minnesota

Maple, Plexiglas, nylon screen

H 13⅝ in., W 15⅝ in., D 47⅝ in.

Scale: ¼ in. to 1 ft.

Gift of Kenneth and Judy Dayton 97.53

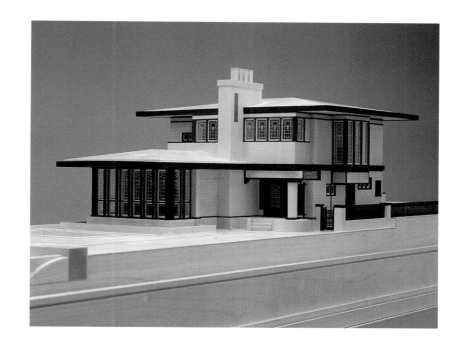

This model represents the Purcell-Cutts house on its site, a lot 50 feet wide and 150 feet long. It shows the house around 1915, during the time the Purcells lived there, and so does not include the garage, which was added later by the Cutts family (on the lot's northwest corner, where the sidewalk meets the alley). On the second-floor front façade can be seen one of the small, plain, square windows inserted when Purcell added a Pullman-style bed for his son James.

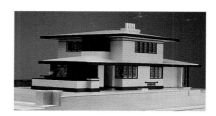

TOP TO BOTTOM

NORTH SIDE, WITH SERVICE ENTRANCE

SOUTHWEST VIEW, SHOWING SCREENED BACK PORCH AND UPSTAIRS SLEEPING PORCH

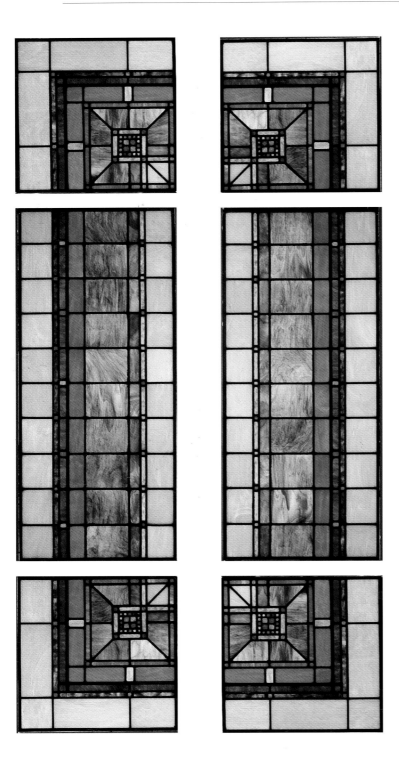

24.

SIX SKYLIGHT PANELS 1913

DESIGNERS: William Gray Purcell (American, 1880–1965) and George Grant Elmslie (American, b. Scotland, 1869–1952)

MAKER: Mosaic Art Shops (E. L. Sharretts), Minneapolis, 1912–30

Glass, zinc caming

(98.225.1,2) H 18 in., W 42 in.; (98.225.3–6) H 18 in., W 18 in.

From the Madison State Bank, Madison, Minnesota (demolished 1968); Purcell, Feick and Elmslie, architects

Gift of funds from Mrs. Eunice Dwan 98.225.1–6

These panels are from the central skylight located over the teller cages of the Madison State Bank. The skylight comprised nine panels: a square central panel, now missing; the four square panels shown here, which formed the corners; and four long border panels linking the corners, of which two are missing and two are shown here. The linear design was continuous throughout the eight outer panels.

For the Madison State Bank, Purcell, Feick and Elmslie produced a long, narrow plan for the middle of a block. The exterior featured a window wall with aqua, orange, and yellow terra-cotta ornament enlivening the brick façade. This was similar to Purcell and Elmslie's other bank designs and indeed to Louis Sullivan's National Farmers' Bank in Owatonna. The teller cages, in the center of the Madison bank, were framed in quartersawn oak panels terminating in light standards akin to those designed for other commissions, notably the Edna S. Purcell house (Purcell-Cutts house). Next to the teller cages Purcell placed his patented phone booth, accessible to both the public and the bank workers by means of a swinging door, but with no pass-through. The bank president's office, though at the very back of the building, had a direct view of the front door so the president could greet clients personally as they entered. The architects even included a specially designed vault that allowed air to enter if someone were locked inside during a robbery. Writing about the commission later, Purcell expressed his satisfaction with these innovations.

Light standards from the bank, three panels from the front windows of the façade, and panels from another skylight (originally in the passage between the banking room and the president's office) are in private collections.

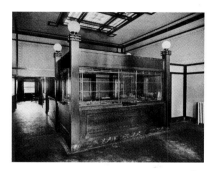

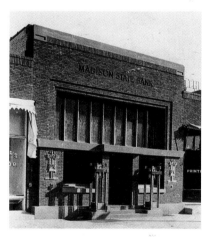

TOP TO BOTTOM

TELLER BOOTH WITH SKYLIGHT

MADISON STATE BANK, MADISON, MINNESOTA

RELEVANT TEXTS

Brooks, *The Prairie School*, p. 227.

Conforti, *Minnesota 1900*, pp. 260–61, illus. following p. 224.

Spencer, *The Prairie School Tradition*, pp. 133–35.

PROVENANCE

Madison State Bank, Madison, Minnesota

David and Patricia Gebhard

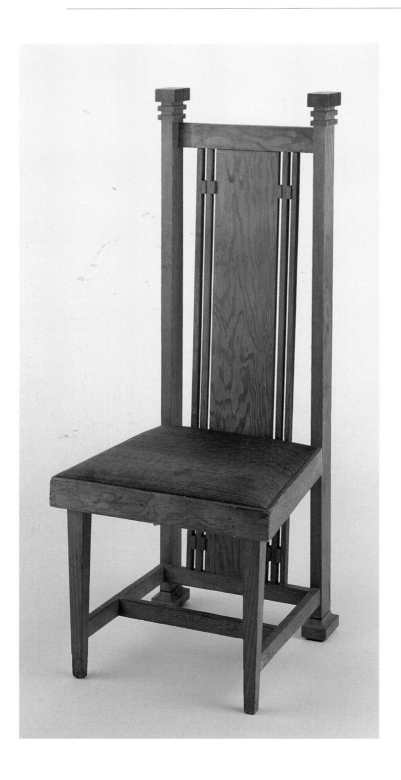

25.

SET OF FOUR SIDE CHAIRS

about 1914

DESIGNERS: William Gray Purcell
(American, 1880–1965) and George Grant
Elmslie (American, b. Scotland, 1869–1952)

Pine, oak, birch, horsehair upholstery

Each: H 50 in., W 19¼ in., D 20 in. (one is
shown)

From the Edward W. Decker house, Wayzata,
Minnesota (demolished 1948, service building
still standing); Purcell and Elmslie, architects

Gift of Susan Decker Barrows 93.89.1–4

In 1913 Purcell and Elmslie built a summer residence for Edward W. Decker, a Minneapolis banker, on a wooded lot on Lake Minnetonka. The dining room, on the first floor, from which the Institute's four chairs came, was paneled in pine and had two built-in buffets. Much of the lower level had an open plan, and the Deckers wanted the floor to be suitable for dancing. In a functional nod to the past, Purcell and Elmslie paved the floors with ceramic tile from the 1870s—found in a Minneapolis warehouse—which Purcell described as having "good organic patterns and beautiful flat eggshell surface." The second floor was equally suited for company, with seven bedrooms and three baths.

In retrospect, Purcell expressed surprise that a man in Decker's business and of Decker's social standing would employ Purcell and Elmslie's firm to develop his country estate; often such men wanted a conservative Tudor manor or Mediterranean palazzo. Nonetheless, the architects were pleased to receive the commission. "It was our first opportunity in Minneapolis to do a distinguished and extensive layout," Purcell later wrote, "and Mr. Decker spent all the money that was necessary to make our architectural thesis complete in all its detail." The Deckers generally approved the firm's recommendations, so that the result was what Purcell called "really an integral work in every department."

▼

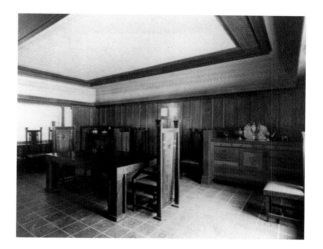

TOP TO BOTTOM

DINING ROOM OF THE DECKER HOUSE

EDWARD W. DECKER HOUSE, WAYZATA, MINNESOTA

Regarding the dining set, Purcell wrote, "We had a beautiful opportunity to design some special furniture, both built-in and free. Made a real blunder and learned a lesson in the dining room [arm] chairs, where the arms bumped your finger against the under side of the table apron." The side chairs are unlike any other furniture by Purcell and Elmslie. They are constructed of pine, a wood appropriate for a summer house, with seats upholstered in hard-wearing horsehair, once a deep blue. The backs have no decorative design. The molding on the side-rail terminals and on the feet matched that on the built-in buffets.

This substantial house was unfortunately torn down in 1948. A service building, connected to the main house by a breezeway, still stands and contains a garage, servants' quarters, and other service areas. Purcell and Elmslie had built a similar residence, often called the "airplane house," for Harold and Josephine Crane Bradley at Wood's Hole, Massachusetts, in 1912, which still stands.

The Minnesota Historical Society has one of the library tables Purcell and Elmslie designed for the Deckers' living room.

RELEVANT TEXTS

Conforti, *Minnesota 1900*, pp. 250–52, 283.

EXHIBITIONS

Prairie School Architecture in Minnesota, Iowa, and Wisconsin,

Minnesota Museum of Art, St. Paul, 1982

Minnesota 1900: Art and Life on the Upper Mississippi, 1890–1915,

The Minneapolis Institute of Arts, 1994

PROVENANCE

Edward W. and Susie M. Spaulding Decker

Susan Decker Barrows

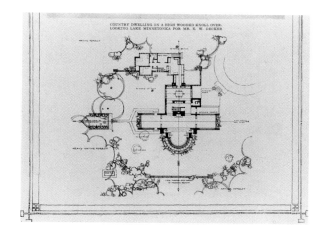

PLAN OF THE DECKER HOUSE, SHOWING PLACEMENT OF
DINING ROOM FURNITURE

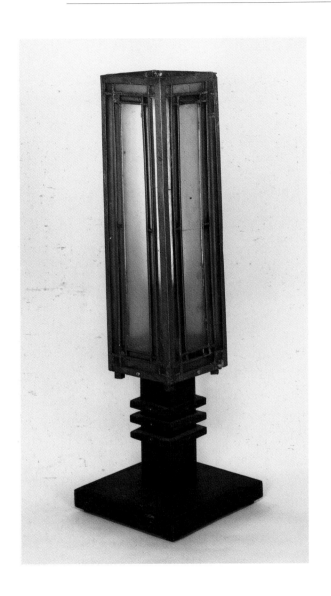

26.

LIGHT FIXTURE 1914

DESIGNERS: William Gray Purcell
(American, 1880–1965) and George Grant Elmslie
(American, b. Scotland, 1869–1952)

MAKER: Mosaic Art Shops (E. L. Sharretts), Minneapolis,
1912–30 (glass)

Glass with zinc caming, wood

H 22 in., W 6½ in., D 6½ in.

From the Minnesota Phonograph Company
(demolished 1979)

Gift of David and Patricia Gebhard 98.235.2

In 1914, Purcell and Elmslie remodeled three Edison shops: the
Minnesota Phonograph Company in Minneapolis, the Edison
Shop in Kansas City, and the Edison Shop in San Francisco, all
independently owned. Each of these commissions required a
complete, integrated design—architecture, furniture, textiles,
wall moldings, and lighting fixtures—in an early attempt to use
attractive contemporary architecture to market a product. The firm
had previously remodeled the Chicago Edison Shop, in the Bab-
son Brothers Building at 229 South Wabash Avenue in Chicago.

This light fixture came from the Minnesota Phonograph Company, an Edison dealership at 612 Nicollet Avenue, in Minneapolis, owned by Lawrence H. Lucker. Several such lamps were mounted on top of wooden grille screens in the shop. The rectilinear shape, stained glass, and horizontal wood banding linked the lamps to the surrounding architecture and furniture. Ironically, the phonograph cabinets themselves looked very old-fashioned in their modern setting.

RELEVANT TEXTS

Brooks, *The Prairie School*, pp. 224–27.

Conforti, *Minnesota 1900*, pp. 262–65, 284–85.

EXHIBITIONS

Minnesota 1900: Art and Life on the Upper Mississippi, 1890–1915,
 The Minneapolis Institute of Arts, 1994

PROVENANCE

Lawrence H. Lucker

David and Patricia Gebhard

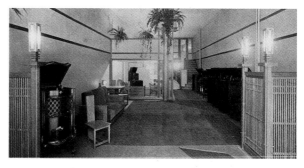

TOP TO BOTTOM

MINNESOTA PHONOGRAPH COMPANY, MINNEAPOLIS

MINNESOTA PHONOGRAPH COMPANY INTERIOR

27.

SECTION OF A FRIEZE 1916

DESIGNER: George Grant Elmslie
(American, b. Scotland, 1869–1952)

MAKER: American Terra Cotta and
Ceramic Company, Terra Cotta, Illinois,
1881–1929 (continued as American Terra
Cotta Corporation until 1966)

Polychromed glazed terra-cotta

H 10 in., W 10 in., D 21 in.

From the Farmers and Merchants Bank, Hector, Minnesota; Purcell and Elmslie, architects
Gift of the Security State Bank, Hector, Minnesota, through the auspices of Mr. David Spreiter

73.18

Looking at a photograph of the Farmers and Merchants Bank of Hector in 1942, William Gray
Purcell saw "not only what we did but what a genial old country banker was happy to have us do
for him in 1916." Purcell and Elmslie had acquired a reputation for being able to deliver an artistic
effect with inexpensive materials. Commissions for small country banks like the one in Hector forced
them to reconsider the use of unified plans calling for custom-designed furniture, fixtures, windows,
and textiles. It was simply too expensive. And the fact that only the wealthy could afford custom-
designed, handmade goods conflicted with the Prairie School's fundamentally democratic aim of
providing good design for the average person. A compromise was called for.

For the Hector bank, the firm decided to purchase ready-made office furniture from the Library
Bureau Company and to design the interior to harmonize with the furniture. The result pleased both
the architects and the client. Purcell felt that they had "eliminated a certain caprice in design on our
part which even with the best of intentions it was sometimes hard to avoid, and thus put ourselves
in line with the more subtle pressures of the American scene."

These decorative terra-cotta tiles for the bank's exterior were designed by George Grant Elmslie in his own style of organic ornamentation, developed during twenty years as Louis Sullivan's chief draftsman. Stylized plant forms combined with geometric patterns, repeated throughout the façade, separate the brick lower level from the light stucco second story.

These tiles were removed in 1970, when the bank was remodeled. Identical fragments are in the Minnesota Museum of American Art in St. Paul and in the Northwest Architectural Archives at the University of Minnesota, Minneapolis.

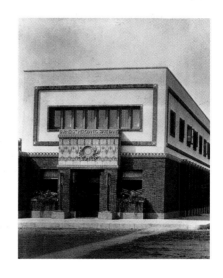

FARMERS AND MERCHANTS BANK,
HECTOR, MINNESOTA

RELEVANT TEXTS

Conforti, *Minnesota 1900*, p. 288.

Prairie School Architecture in Minnesota, Iowa, Wisconsin, p. 67.

EXHIBITIONS

Purcell and Elmslie, Architects: Designs for Minnesota, 1909–1917,
 University Gallery, University of Minnesota, Minneapolis, 1978

Prairie School Architecture in Minnesota, Iowa, and Wisconsin,
 Minnesota Museum of Art, St. Paul, 1982

Minnesota 1900: Art and Life on the Upper Mississippi, 1890–1915,
 The Minneapolis Institute of Arts, 1994

PROVENANCE

Farmers and Merchants State Bank, Hector, Minnesota

Security State Bank, Hector, Minnesota

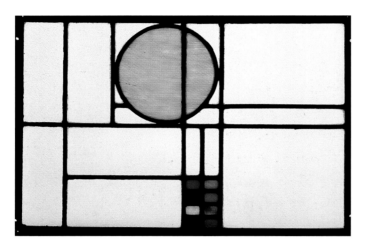 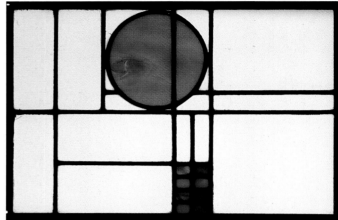

28.

SET OF TWO WINDOWS 1922

DESIGNER: George Grant Elmslie (American, b. Scotland, 1869–1952)

Stained and clear glass, lead caming

Each: H 16¼ in., W 11 in.

From the Capitol Building and Loan Association Building, Topeka, Kansas (demolished 1967);
 George Grant Elmslie, architect

Gift of Roger G. Kennedy 98.256.2.1,2

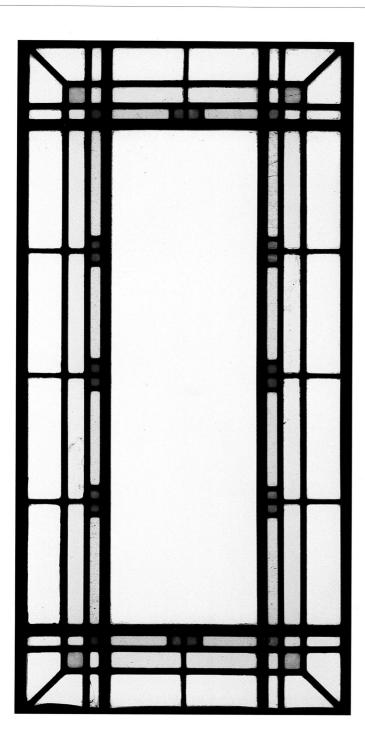

29.

WINDOW 1922

DESIGNER: George
Grant Elmslie (American,
b. Scotland, 1869–1952)

Stained and clear glass, lead
caming

H 32¾ in., W 15¾ in.

From the Capitol Building and
Loan Association Building,
Topeka, Kansas (demolished
1967); George Grant Elmslie,
architect

Gift of Roger G. Kennedy
98.256.3

▼

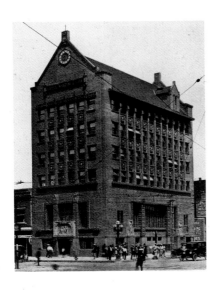

CAPITOL BUILDING AND LOAN
ASSOCIATION BUILDING,
TOPEKA, KANSAS

George Grant Elmslie began drawing up plans for the Capitol Building and Loan Association in 1918, but construction did not begin until 1922, after the firm of Purcell and Elmslie had been dissolved. The lower level is in the style of previous Purcell and Elmslie banks, and the upper stories recall some of Elmslie's past work with Sullivan.

By this time the Prairie School was fast losing ground to modernism. But in the windows for Capitol Building and Loan, Elmslie still used repeated geometric forms and colors to unify the interior and exterior. The larger panes have small colored squares surrounding a central rectangle of clear glass, much like his earlier windows. The smaller panes feature circle motifs and rectangles of varying size, reminiscent of the windows in Frank Lloyd Wright's Avery Coonley playhouse (1912).

RELEVANT TEXTS

Brooks, *The Prairie School*, pp. 306–7.

PROVENANCE

Capitol Building and Loan Association, Topeka, Kansas

Roger G. Kennedy

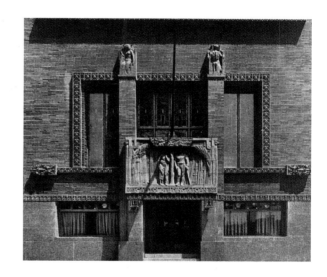

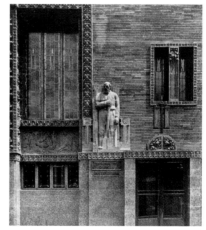

TOP TO BOTTOM

CAPITOL
BUILDING AND
LOAN,
FRONT ENTRY

SIDE ENTRY

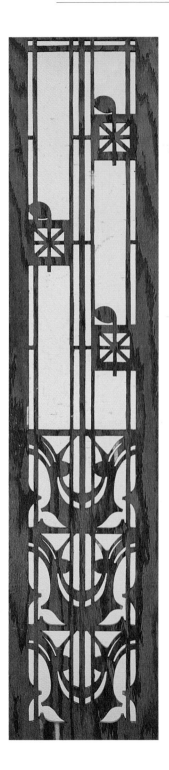

30.

SCREEN FRAGMENT 1928

DESIGNER: George Grant Elmslie (American, b. Scotland, 1869–1952)

Sawed wood

H 64¼ in., W 13¾ in., D ½ in.

From the Western Springs Congregational Church, Western Springs, Illinois;
George Grant Elmslie, architect

Gift of David and Patricia Gebhard 98.235.1

The Western Springs Congregational Church, with its pitched roof and bell tower, was not radically modern like Purcell and Feick's Stewart Memorial Church in Minneapolis (1909), but it was probably very much in step with late 1920s ecclesiastical expectations. It was built in a parklike setting, which Elmslie considered more conducive to worship than a street corner. In the 1950s, the congregation had the chancel altered, adding vertical woodwork to relieve the horizontal emphasis of Elmslie's original interior (a holdover from his Prairie School work). The screen from which this fragment came was probably removed then. The sawed-wood musical notes have the playful spirit of Elmslie's Prairie School designs, like the ESP monogram at the Purcell-Cutts house.

PROVENANCE

Western Springs Congregational Church, Western Springs, Illinois

David and Patricia Gebhard

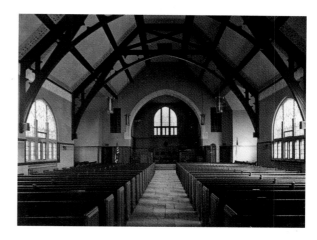

TOP TO BOTTOM

WESTERN SPRINGS CHURCH INTERIOR

WESTERN SPRINGS CONGREGATIONAL CHURCH, WESTERN SPRINGS, ILLINOIS

31.

CASEMENT WINDOW 1910

DESIGNER: George Washington Maher
 (American, 1864–1926)

Oak frame, glass, lead caming

H 25 in., W 11¾ in., D 1¹¹⁄₁₆ in.

From the Charles J. Winton, Sr., house, Minneapolis;
 George Washington Maher, architect

Gift of Henry and Elizabeth Hyatt 98.255.2

George Washington Maher apprenticed in the Chicago offices of Joseph Lyman Silsbee, where Wright and Elmslie were both working as draftsmen. Maher opened his own practice in 1888 at the age of twenty-three. Like his Prairie School colleagues, he believed that architectural form should follow function and that American architects should strive to create a new vocabulary of forms. Maher's work incorporated his ideals of symmetry, mass, and centralization.

Maher had designed a house for Charles and Helen Winton in Wausau, Wisconsin. The Wintons liked it so much that when they moved to Minneapolis they asked him for another just like it. Built in 1910, the Minneapolis house has overhanging eaves and a low, horizontal roofline and entryway, all typical Prairie-style features. This window is from a bank of three, overlooking the main staircase, that allowed light into the closet of the master bedroom. The poppy motif appeared throughout the house. During a recent restoration these windows were removed, and one was given to The Minneapolis Institute of Arts.

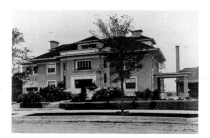
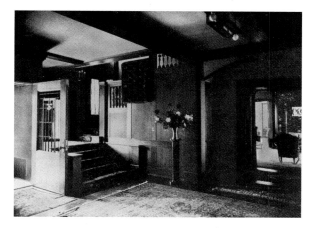

Of the other two windows, one was donated to Pleasant Home, a Maher house and museum in Oak Park, Illinois, and one was retained by the last owner.

RELEVANT TEXTS

Brooks, *The Prairie School*, pp. 34–37, 105–12.

PROVENANCE

Charles J. Winton, Sr., and Helen Smith Winton

Winton family

Henry and Elizabeth Hyatt

CLOCKWISE FROM LEFT

GEORGE W. MAHER

CHARLES J. WINTON, SR., HOUSE, MINNEAPOLIS

WINTON HOUSE INTERIOR

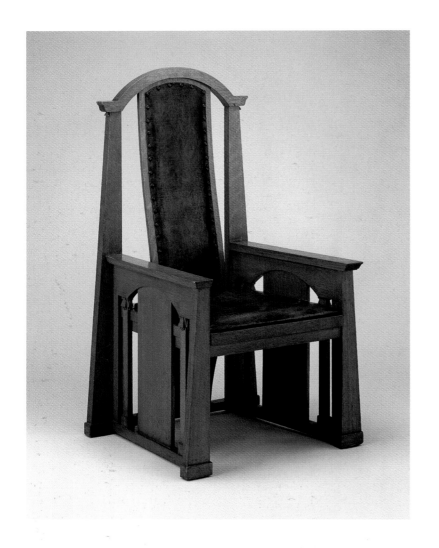

32.

ARMCHAIR about 1912

DESIGNER: George Washington Maher
(American, 1864–1926)

Oak, leather

H 46¼ in., W 25⁵⁄₁₆ in., D 22 in.

From Rockledge, the E. L. King house,
Homer, Minnesota (demolished 1987);
George Washington Maher, architect

The Anne and Hadlai Hull Fund, gift of
Mr. and Mrs. Sheldon Sturgis, and gift
of Mr. and Mrs. Henry Hyatt 88.45

George Maher developed a unified scheme of architecture and furnishings for Rockledge, a house built in 1912 near Winona, Minnesota, for the businessman Ernest L. King and his wife, Grace Watkins King. Mrs. King's father was the founder of the J. R. Watkins Company, originally a manufacturer of patent medicines, which still thrives today.

Above the central doorway of Rockledge, Maher used a flattened arch, a commanding architectural element that echoed the solidity of the bluffs looming just behind the house. He adopted the tiger lily, abundant at the site, as a motif for decorations within the house. Maher's "motif-rhythm" theory took the idea of a unified interior, as practiced by Wright, Purcell, Elmslie, and other Prairie School architects, a step further. Maher believed that repeating a few motifs consistently throughout the house, so that one was surrounded with them, would make the home—and therefore one's life—harmonious.

Because the Kings were among his wealthiest clients, Maher designed lavish interior details and nearly every object that would be used at Rockledge. The flattened arch and the tiger lily were the prevailing motifs of the interior architectural elements, the furnishings, and a multitude of everyday objects. Maher designed this armchair to reflect the architecture of Rockledge in its trapezoidal form and flattened arches. Though Rockledge was demolished in 1987, its furnishings were saved, and they, along with period photographs, illustrate Maher's remarkable realization of his version of a unified interior.

By the 1930s Maher's design scheme was out of vogue, and the Kings redecorated Rockledge in the fashionable Art Deco style. At the time Rockledge was built, however, the Watkins family had admired Maher's symmetrical, classical Prairie School approach enough to commission two other buildings from him: the J. R. Watkins Company Administration Building (1911) and the Winona Savings Bank (1914). Both still stand in Winona and serve their original functions.

A similar chair is in the collection of the Metropolitan Museum of Art in New York, and the Minnesota Historical Society has a billiard chair.

▼

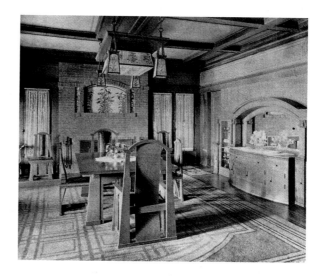

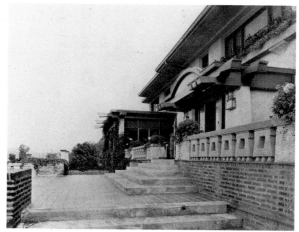

TOP TO BOTTOM

DINING ROOM OF ROCKLEDGE

ROCKLEDGE, THE E. L. KING HOUSE, HOMER, MINNESOTA

RELEVANT TEXTS

Bahnemann, "George Maher's Rockledge," pp. 30–34.

Conforti, *Minnesota 1900*, pp. 59–60.

From Architecture to Object, pp. 78–79.

Hollander, "Rockledge," pp. 13–15.

Kaplan, *"The Art That Is Life,"* pp. 47, 94, 95, 396–400.

Kardon, *The Ideal Home*, pp. 74–75, 225.

Maher, "An Architecture of Ideas," p. 46.

Volpe and Cathers, *Treasures of the American Arts and Crafts Movement*,

 pp. 17, 61–63.

EXHIBITIONS

Minnesota 1900: Art and Life on the Upper Mississippi, 1890–1915,

 The Minneapolis Institute of Arts, 1994

PROVENANCE

Ernest L. and Grace Watkins King

Robert Edwards, Philadelphia (dealer)

Hirschl and Adler Galleries, Inc., New York (dealer)

33.

COFFEE AND TEA SERVICE about 1912

DESIGNER: George Washington Maher (American, 1864–1926)

MAKER: Gorham Manufacturing Company, Providence, Rhode Island, 1831–present

Silver, ivory

Coffeepot: H 9½ in., W 8¾ in., Diam 4¾ in.; slop bowl: H 3¼ in., Diam 4⅜ in.; hot-water kettle: H 9½ in., W 8½ in., Diam 5⅝ in.; kettle stand: H 6¼ in., Diam 6⅝ in.; warming unit: H 1¾ in., L 5¼ in., Diam 2⁹⁄₁₆ in.; creamer: H 4¾ in., W 5¼ in., Diam 3⅝ in.; sugar bowl: H 3½ in., W 6 in., Diam 4⁹⁄₁₆ in.; sugar lid: H 1¾ in., Diam 3¾ in.; teapot: H 7¾ in., W 8⅞ in., Diam 5 in.; tray: L 29⅜ in., W 20 in.

▼

Marks: "Martelé"/Gorham lion, anchor with spread-winged eagle above, Gothic letter G/
".9584/ZBY/Spaulding & Co./Chicago" (all pieces except heating element; kettle base lacks
"Spaulding & Co."); "Gorham/Sterling P/patent applied for" (heating element)
From Rockledge, the E. L. King house, Homer, Minnesota (demolished 1987);
George Washington Maher, architect
Gift of Bruce B. Dayton in honor of Russell A. Plimpton 95.36.1–7

The coffee and tea service that Maher designed for Rockledge illustrates his adherence to the progressive idea of a unified interior. Emblazoned on each piece, along with the King monogram, is the ubiquitous tiger lily, one of Maher's dominant motifs for the house. Every piece also has the trapezoidal dentils, or guttae, that Maher used as architectural detailing, notably on a balustrade in the front. The handle of the hot-water kettle echoes the flattened arch so prominent on Rockledge's exterior, thus linking the building's furnishings with its façade.

Because King supported his architect's vision, Maher was able to have the silver service manufactured to the highest standards. It was custom-made by the Gorham Manufacturing Company as part of Gorham's exclusive "Martelé" line, which combined the popular Art Nouveau and Arts and Crafts styles of the time with traditional silversmithing techniques. The visibly hand-hammered surface is characteristic of Arts and Crafts metalwork. The price from the retailer, Spaulding and Company of Chicago, was thirteen hundred dollars. Serving pieces and flatware were produced to match.

With its strong architectural presence and excellent design and craftsmanship, this service formed an integral part of one of the region's most progressive turn-of-the-century interiors. It is one of the only known examples of Prairie School silver.

RELEVANT TEXTS

Bahnemann, "George Maher's Rockledge," pp. 34, 39–40.

Conforti, *Minnesota 1900*, pp. 50, 59–60.

Gustafson, Eleanor H., "Museum Accessions," *Antiques* (January 1996): 36.

Kaplan, *"The Art That Is Life,"* pp. 48, 94, 95, 396–400.

Kardon, *The Ideal Home*, pp. 74–75, 205.

Komar, Jennifer, "The Rockledge Coffee and Tea Service: An Integral Part of George
Maher's Progressive Interior," in 12th Annual Antiques Show and Sale catalogue,
Decorative Arts Council of The Minneapolis Institute of Arts, 1995, pp. 6–7.

Volpe and Cathers, *Treasures of the American Arts and Crafts Movement*, pp. 17, 61–63.

EXHIBITIONS

The Ideal Home: 1900–1920, American Craft Museum, New York, 1993–94

Minnesota 1900: Art and Life on the Upper Mississippi, 1890–1915,
The Minneapolis Institute of Arts, 1994

PROVENANCE

Ernest L. and Grace Watkins King

Historical Design Collection, New York (dealer)

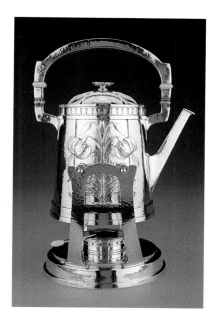

HOT-WATER KETTLE AND STAND
FROM ROCKLEDGE

34.

CARPET RUNNER about 1912

DESIGNER: George Washington Maher
(American, 1864–1926)

Linen and wool

L 33 ft. ¾ in., W 3 ft. 10½ in. (detail is shown)

From Rockledge, the E. L. King house, Homer, Minnesota
(demolished 1987); George Washington Maher, architect

The William Hood Dunwoody Fund 91.143

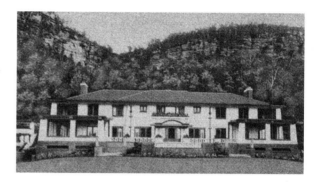

ROCKLEDGE, THE E. L. KING HOUSE, HOMER, MINNESOTA

Maher designed several rugs for Rockledge, all woven in geometric patterns to complement the architecture. Placed throughout the house, they helped unify the interior. This runner has the same geometric border and color palette as the other rugs but lacks their central geometric jacquard pattern.

RELEVANT TEXTS

Conforti, *Minnesota 1900*, pp. 59–60.

Kaplan, "*The Art That Is Life,*" p. 221.

EXHIBITIONS

Minnesota 1900: Art and Life on the Upper Mississippi, 1890–1915,
The Minneapolis Institute of Arts, 1994

PROVENANCE

Robert Edwards, Philadelphia (dealer)

Capitol Arts and Antiques, St. Paul, Minnesota (dealer)

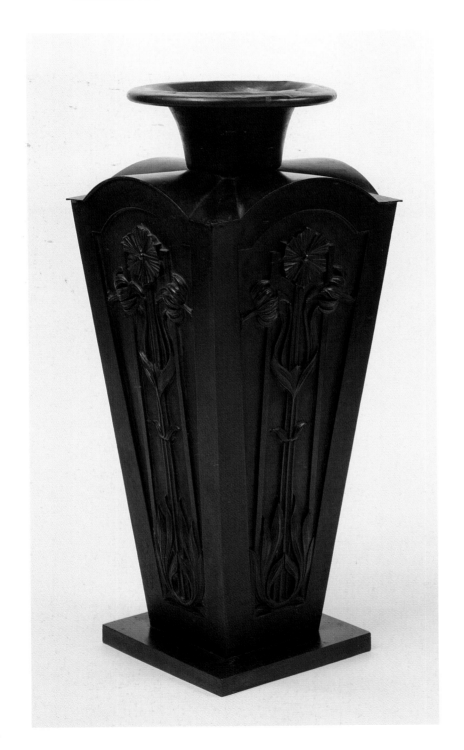

35.

URN about 1912

DESIGNER: George Washington Maher
(American, 1864–1926)

Bronze, copper

H 30½ in., W 12½ in., D 12½ in.

From Rockledge, the E. L. King house, Homer, Minnesota
(demolished 1987); George Washington Maher, architect

The Modernism Collection, gift of Norwest Bank Minnesota
98.276.6

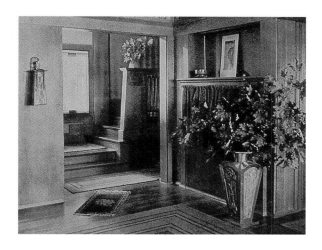

URN AT ROCKLEDGE

This urn has the tiger lily and arch motifs of Maher's decorative
scheme for Rockledge. Interior photos of the house show an urn
holding an arrangement of prairie plants and flowers.

RELEVANT TEXTS

Duncan, *Modernism*, p. 43.

Kaplan, *"The Art That Is Life,"* pp. 48, 94, 95, 396–400.

Kardon, *The Ideal Home*, pp. 74–75, 192.

Volpe and Cathers, *Treasures of the American Arts and Crafts Movement*, pp. 17, 61–63.

EXHIBITIONS

The Ideal Home: 1900–1920, American Craft Museum, New York, 1993–94

Milestones of Modernism, 1880–1940: Selections from the Norwest Collection,
The Minneapolis Institute of Arts, 1999

PROVENANCE

Historical Design, Inc., New York (dealer)

Norwest Corporation, Minneapolis

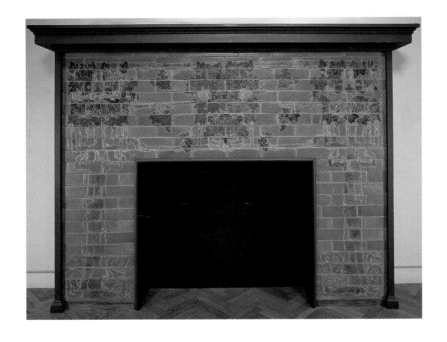

36.

FIREPLACE SURROUND

1902

DESIGNER: Attributed to John S. Bradstreet (American, 1845–1914)

MAKER: Grueby Faience Company, Boston, 1897–1909

Glazed ceramic

W 84¾ in., H 67½ in. (without frame)

From the Sellwood-Leithhead house, Duluth, Minnesota; Palmer, Hall, and Hunt, architects

Gift of the Decorative Arts Council 91.47

This fireplace surround is from the Duluth house of Othelia and Lesley Leithhead. Mrs. Leithhead's father, Captain Joseph Sellwood, commissioned the Duluth architects Palmer, Hall, and Hunt to design the house in 1902 as a wedding gift for the Leithheads. The tiled scene of two trees with expressively twisted roots was produced by the Grueby Faience Company, then one of the prominent manufacturers of art pottery and architectural ceramics. The complexity of the design and the use of brick-shaped tiles are unusual in American ceramic work.

The surround is attributed to the Minneapolis-based interior designer John Bradstreet for several reasons. The tree motif is similar to Bradstreet's compositions for the leaded glass in Glensheen (1908–9), the Chester Congdon mansion, also in Duluth, and for the smoking-room fireplace surround of the Edson S. Woodworth residence (1908) on Pillsbury Avenue in Minneapolis. Furthermore, the Grueby company used outside artists during its early years and may well have turned to Bradstreet, a Massachusetts man who retained his East Coast connections after settling in Minneapolis.

Bradstreet's living room from the William Prindle house in Duluth is now one of the period rooms in The Minneapolis Institute of Arts.

RELEVANT TEXTS

Conforti, *Minnesota 1900*, p. 83.

From Architecture to Object, p. 62.

Gustafson, Eleanor H., "Museum Accessions," *Antiques* (September 1991): 300.

Volpe and Cathers, *Treasures of the American Arts and Crafts Movement*, pp. 88, 90, no. 56.

EXHIBITIONS

From Architecture to Object: Masterworks of the American Arts and Crafts Movement,
 Hirschl and Adler Galleries, New York, 1989; Struve Gallery, Chicago, 1989–90

Minnesota 1900: Art and Life on the Upper Mississippi, 1890–1915,
 The Minneapolis Institute of Arts, 1994

PROVENANCE

Mr. and Mrs. Lesley W. Leithhead, 1902–46

Sellwood-Leithhead mansion, Duluth, Minnesota, 1946–87

Hirschl and Adler Galleries, Inc., New York, 1987–91 (dealer)

37.

MONUMENTAL VASE about 1905–10

DESIGNER: William D. Gates (American, 1852–1935)

MAKER: Gates Potteries, Terra Cotta, Illinois, for the Teco
ware line, about 1885–about 1922; shape 416

Glazed earthenware

H 18 in., Diam 10½ in.

Marks: Signed with impressed block (four markings)

The Modernism Collection, gift of Norwest Bank Minnesota
98.276.7

UNMOLDING TECO WARE AT GATES POTTERIES, ABOUT 1905

In 1901, Gates Potteries introduced a line of green art pottery, following the Grueby Faience Company's lead of 1897 (see no. 36). Teco (pronounced tee-co), the trademark name for this line (from *terra* and *cotta*), came to signify a confluence of talent and technology. Teco's crystalline glaze was the result of a series of experiments in a variety of colors, with green proving most successful. Unlike Grueby, however, Teco emphasized form rather than glaze—the reason, no doubt, why Teco pottery was seen in interiors planned by America's leading architects. Some architects, including William B. Mundie, Howard Van Doren Shaw, Hugh M. G. Gardner, and Max Dunning, even contributed designs for Teco ware. At least one model for the line is from the hand of Frank Lloyd Wright.

▼

The vase pictured here—one of the largest and finest examples of Teco—was designed by the firm's founder, William D. Gates. Its severe architectonic form, subtle glaze, and restrained decoration placed it far ahead of its time. Gates also collaborated with George Grant Elmslie on the terra-cotta work for the interior of the National Farmers' Bank in Owatonna, Minnesota (1907–8).

William Gates achieved the democratic goals of the Arts and Crafts movement by manufacturing pottery with molds, which allowed mass-production and greater quality control. The result was a well-designed product that middle-class people could afford.

Gates Potteries was a subsidiary of the American Terra Cotta and Ceramic Company, which William Gates had founded in 1881. While American Terra Cotta specialized in architectural forms, Gates Potteries produced garden pottery and the Teco line of art ware. In the early 1920s, an increasing demand for architectural terra-cotta left little time for making art pottery, and production of the Teco line ceased.

RELEVANT TEXTS

Bowman, *American Arts and Crafts*, pp. 204–5.

Darling, *Teco*, pp. 22, 157.

Duncan, *Modernism*, p. 42, 56.

From Architecture to Object, pp. 98–99.

Kaplan, "*The Art That Is Life*," pp. 228, 260, 387.

Volpe and Cathers, *Treasures of the American Arts and Crafts Movement*, pp. 21, 85, 98–102.

EXHIBITIONS

Modernism at Norwest, Norwest Center, Minneapolis, 1989–90

Teco: Art Pottery of the Prairie School, Erie Art Museum, Erie, Pennsylvania, 1989;

 Chicago Historical Society, 1990

Modernist Ceramics: 1880–1940, Norwest Center, Minneapolis, 1990–91

Milestones of Modernism, 1880–1940: Selections from the Norwest Collection,

 The Minneapolis Institute of Arts, 1999

The Clay Vessel: Modern Ceramics from the Norwest Collection, 1880–1940,

 Denver Art Museum, 1999–2000

PROVENANCE

Norwest Corporation, Minneapolis

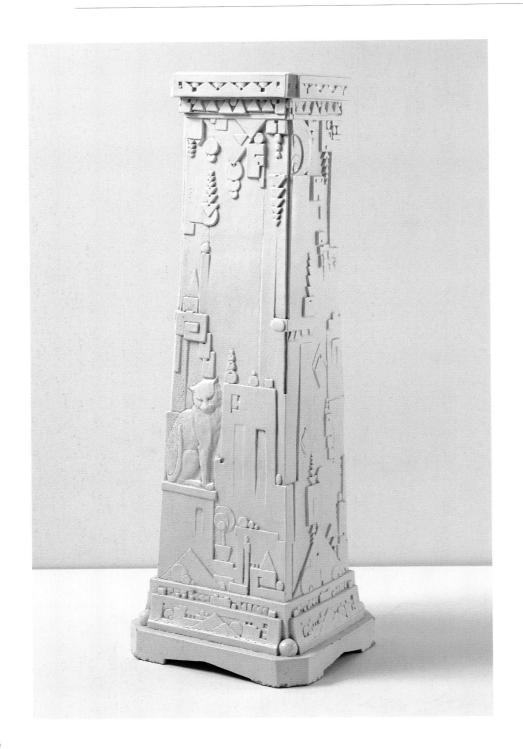

38.

PEDESTAL about 1911

DESIGNER: Fernand Moreau (American, b. France, 1853–1920)

MAKER: Northwestern Terra Cotta Company (Norweta), Chicago, 1884–1956

Glazed terra-cotta

H 38½ in., W 13 in., D 12 in.

The Modernism Collection, gift of Norwest Bank Minnesota 98.276.8

Fernand Moreau, the designer of this pedestal, trained as a sculptor in his native France before immigrating to America in 1880. Moreau opened a studio in Washington, D.C., and then moved to Chicago sometime before the 1893 World's Fair. By 1902 he was teaching ornamental modeling at the School of the Art Institute of Chicago. In 1904 he went to work for Gates Potteries, joining Fritz Albert, the factory's chief modeler. Albert left for the Northwestern Terra Cotta Company in 1906, and Moreau followed a few years later.

This pedestal was designed as a base for a molded terra-cotta lamp featuring a seminude female figure by Fritz Albert. At some point over the years, pedestal and lamp were separated. The cast decoration of the base consists of an imaginary Egyptian cityscape and a stylized cat and owl.

RELEVANT TEXTS

Duncan, *Modernism*, p. 58.

PROVENANCE

Historical Design, Inc., New York (dealer)

Norwest Corporation, Minneapolis

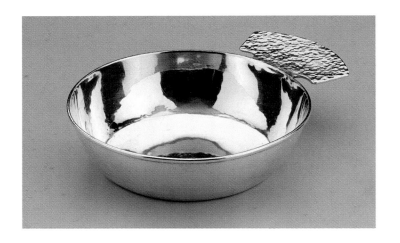

39.

PORRINGER about 1905–14

MAKER: Kalo Shop, Park Ridge and Chicago, Illinois, 1900–1970

Silver

H 1⁹⁄₁₆ in., W 6¹¹⁄₁₆ in., Diam 5¼ in.

Marks: "Sterling/Hand Beaten/at/Kalo Shops/ Park Ridge/Ills./6289"

The Ethel Morrison Van Derlip Fund 97.118

The Kalo Shop was founded in 1900 by Clara Pauline Barck, a graduate of the School of the Art Institute of Chicago. (*Kalo* is the Greek word for beautiful.) To begin with, the shop's workers, who were mainly women, made primarily leatherware and jewelry. In 1905, Barck married George Welles, an amateur metalsmith, and together they established the Kalo Art-Craft Community at their home in Park Ridge, Illinois. The community was both school and shop, producing textiles, baskets, jewelry, and silverware for sale in its downtown Chicago showrooms. Clara Welles hired trained silversmiths, many of Scandinavian descent, to execute her designs. In 1914, Welles moved her operation from Park Ridge to Chicago and concentrated exclusively on jewelry and metalwork. She was known for her fair employment practices and for encouraging women to become metalsmiths. Welles retired in 1940, but the Kalo Shop continued until 1970, serving as Chicago's leading producer of silverware for more than three generations.

The porringer, a shallow cup or bowl, is a form dating back to the seventeenth century. In eighteenth-century America, porringers of silver, pewter, brass, and cast iron were used for serving porridge or gruel to infants and invalids. The visible hand-hammering on this porringer sets it apart from its historical precursors and identifies it with the Arts and Crafts movement. Hammer-textured surfaces emphasized handcraftsmanship and symbolized rejection of machine-made objects.

RELEVANT TEXTS

Darling, *Chicago Metalsmiths*, pp. 39, 40, 45–55, 79, 85, 97, 102, 104.

Kaplan, "*The Art That Is Life,*" pp. 163, 227, 279–80, 284.

Volpe and Cathers, *Treasures of the American Arts and Crafts Movement*,
 pp. 17–18, 146–50, 99–101.

PROVENANCE

Pillsbury-Michel, Inc., Houston, Texas (dealer)

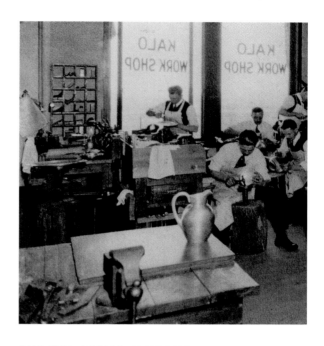

KALO SHOP, CHICAGO, ABOUT 1917

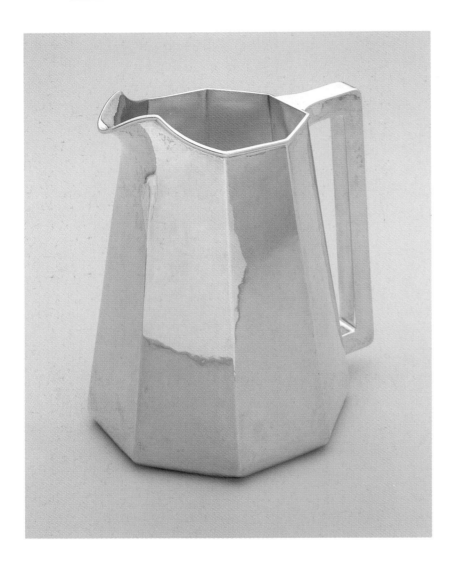

40.

PITCHER 1916

DESIGNER: Clara Barck Welles
(American, 1868–1965)

MAKER: Kalo Shop, Park Ridge and
Chicago, Illinois, 1900–1970

Silver

H 7½ in., W 6½ in., Diam 5⅝ in.

Marks: "Sterling/Hand Wrought/at/the
Kalo Shops/Chicago/and/New
York/18"; inscription: "April 27,
1916"

The Modernism Collection, gift of
Norwest Bank Minnesota 98.276.9

Deceptively simple in appearance, this octagonal pitcher was carefully constructed to present a sleek, modern silhouette devoid of decoration. The seams of the eight separate vertical panels are perfectly aligned, with slightly rounded corners, and each panel is smoothly tucked under at the bottom. The handle echoes the geometry of the panels but curves gently inward at the points of attachment, softening the line. The Kalo design recalls the rectilinear vessels of Charles R. Ashbee's Guild of Handicraft and other British Arts and Crafts silvermakers.

KALO MARK ON BOTTOM OF PITCHER

RELEVANT TEXTS

Darling, *Chicago Metalsmiths*, pp. 39, 40, 45–55, 79, 85, 97, 102, 104.

Duncan, *Modernism*, pp. 44, 57–58.

Phillips et al., *High Styles*, pp. 38–39.

EXHIBITIONS

Modernism at Norwest, Norwest Center, Minneapolis, 1990

Women in Modernist Design: 1900–1945, Norwest Center, Minneapolis, 1992–93

Milestones of Modernism, 1880–1940: Selections from the Norwest Collection,
 The Minneapolis Institute of Arts, 1999

PROVENANCE

Historical Design, Inc., New York (dealer)

Norwest Corporation, Minneapolis

41.

PITCHER about 1917

MAKER: Kalo Shop, Park Ridge and Chicago, Illinois, 1900–1970

Silver

H 9½ in., W 8⅛ in., Diam 6¼ in.

Marks: "Sterling/Hand Wrought/at/The Kalo Shop/394/6 Pints" and two E's(?) overlapping

Gift of Dolly J. Fiterman 97.163.2

This softly rounded form is characteristic of raised hollowware produced by the Kalo Shop after 1914. Originally adopted to strengthen the pieces, the shape became a Kalo trademark. The chased leaves or petals that seem almost to grow from the bottom of the pitcher resemble the decoration on contemporary Grueby pottery. The simple beauty and exceptional quality of this and other Kalo products of the time, from hollowware to jewelry to flatware, illustrate the Kalo motto: "Beautiful, useful, and enduring."

RELEVANT TEXTS

Darling, *Chicago Metalsmiths*, pp. 39, 40, 45–55, 79, 85, 97, 102, 104.

Volpe and Cathers, *Treasures of the American Arts and Crafts Movement*, p. 148.

PROVENANCE

Douglas L. Solliday, Columbia, Missouri (dealer)

Dalton's American Decorative Arts, Syracuse, New York (dealer)

42.

NUT SPOON about 1905–18

MAKER: Handicraft Guild of Minneapolis, 1904–18

Silver

L 3⅝ in., W 1⅜ in., D ½ in.

Marks: "Handicraft Guild/Sterling/Minneapolis" on reverse; inscription:
 "BG" on front of handle

The Pflaum Silver Fund 96.117

In Minnesota, economic expansion and population growth in the 1880s and 1890s coincided with an interest in establishing cultural and arts organizations that would enhance people's lives. One of the earliest was the Chalk and Chisel Club, later reorganized as the Arts and Crafts Society of Minneapolis. In 1904 a group of women, several of them Arts and Crafts Society members, formed the Handicraft Guild of Minneapolis.

Like the Kalo Shop and other American Arts and Crafts endeavors, the Handicraft Guild was influenced by C. R. Ashbee's school and Guild of Handicraft, founded in 1888 in London, and by Japanese craft traditions. Emphasis was on the handcraft process and truth to materials. A course catalogue summed up the Handicraft Guild's mission: "[to] give authoritative instruction in design and its solution in terms of materials; also to furnish complete training for students desirous of becoming Craftsmen, Designers and Teachers." The Handicraft Guild was an egalitarian organization, and most objects made by its members were marked only with the cipher HG.

Many important educators and craftspeople were guild members, officers, and instructors. Mary Moulton Cheney, a graphic designer and prominent educator at the guild, later served as director of the Minneapolis School of Fine Arts (now the Minneapolis College of Art and Design). The guild's founder, Emma Roberts, who understood the importance of aesthetics in the lives of children, taught drawing and art appreciation in the Minneapolis public schools for over two decades. From 1905 to 1909, summer school students at the guild were directed by the celebrated ceramic artist and educator Ernest Batchelder of Throop Polytechnic Institute (now the California Institute of Technology), in Pasadena, California.

The Handicraft Guild also offered opportunities for exhibitions, sales, and architectural commissions. Members soon saw that a permanent location was needed, and in 1907 a building, which still stands today, was constructed for the guild at 89 South Tenth Street in downtown Minneapolis. All wares produced by the Handicraft Guild were sold there—metalwork, ceramics, leatherwork, jewelry, stencils, woodblock prints, weavings, and baskets. In 1918, believing that its mission would now be better served through a larger, public institution, the guild arranged for its program to become the University of Minnesota's art education department.

This hand-hammered silver nut spoon has a cutout geometric design that was also used as decoration for nut bowls produced in copper and silver by the guild.

Numerous objects made by the Handicraft Guild of Minneapolis are in the Minnesota Historical Society's collections.

RELEVANT TEXTS

Conforti, *Minnesota 1900*, pp. 122–41.

PROVENANCE

Dalton's American Decorative Arts, Syracuse, New York (dealer)

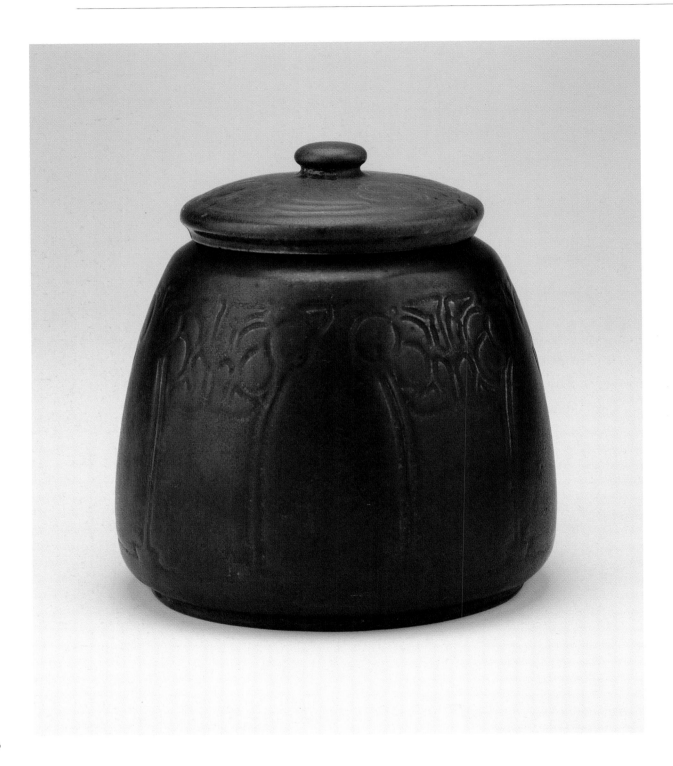

43.

TOBACCO JAR about 1915

DESIGNER: Florence E. Willets (American, active 1905–56)

MAKER: Handicraft Guild of Minneapolis, 1904–18

Ceramic

H 6½ in., Diam 6⅛ in.

Marks: Incised G inside lower half of an H

Gift of Florence E. Willets 16.720

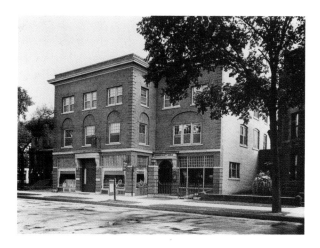

HANDICRAFT GUILD BUILDING, MINNEAPOLIS

This matte blue jar with its molded decoration of stylized leaves has the Handicraft Guild's symbol incised on the bottom. Florence Willets, the artist, gave it to The Minneapolis Institute of Arts in 1916. An accomplished ceramist, Willets served as the secretary-treasurer of the Handicraft Guild of Minneapolis for most of its existence. Her work was featured in the 1906 issue of *The Bellman*, a weekly literary magazine published in Minneapolis.

RELEVANT TEXTS

Conforti, *Minnesota 1900*, pp. 122–41, 154.

EXHIBITIONS

Minnesota 1900: Art and Life on the Upper Mississippi, 1890–1915,
 The Minneapolis Institute of Arts, 1994

PROVENANCE

Florence E. Willets, Minneapolis

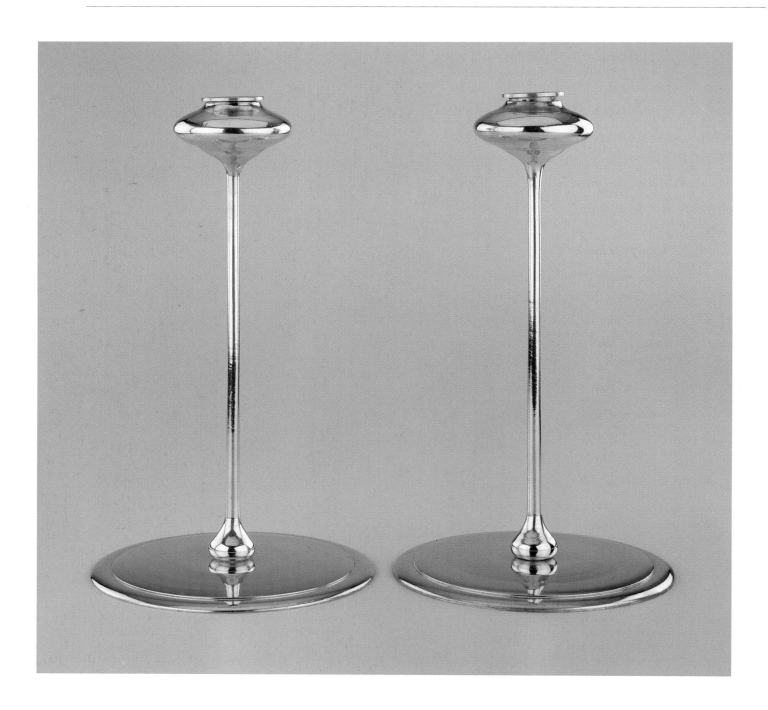

44.

PAIR OF CANDLESTICKS about 1905–18

MAKER: Attributed to the Handicraft Guild of
Minneapolis, 1904–18

Brass

H 11¼ in., Diam 6⅜ in.

Marks: Label, G inside lower half of an H with "Minne/apolis"
below

The T. L. Daniels Memorial Fund 97.44.1,2

A paper label bearing the mark of the Handicraft Guild of Minne-
apolis is affixed to the underside of one of the removable candle
sockets. These candlesticks could have been made by a guild member,
or they could have been consigned for sale in the guild salesroom.
With their tall, slender shafts and budlike holders, they are very
similar to candlesticks made by the firm of Robert Jarvie of Chicago.
A well-known metalsmith and furniture maker, Jarvie produced
lighting fixtures for the living room of the Edna S. Purcell house
(Purcell-Cutts house). So many imitations of Jarvie's candlesticks
appeared on the market in 1903 that he was compelled to inform
readers of *House Beautiful* that all his future work would be signed.

TOP TO BOTTOM

HANDICRAFT GUILD
SALESROOM

HANDICRAFT GUILD
LABEL

RELEVANT TEXTS

Conforti, *Minnesota 1900*, pp. 122–41.

Darling, *Chicago Metalsmiths*, pp. 55–61.

From Architecture to Object, p. 101.

PROVENANCE

Ark Antiques, New Haven, Connecticut (dealer)

45.

VASE about 1912–15

MAKER: Lebolt and Company, Chicago,
1907–about 1942

Silver with glass tube

H 13 in., W 3½ in., D 3½ in.

Marks: "Lebolt/Hand Beaten/Sterling 804"

The Modernism Collection, gift of Norwest
Bank Minnesota 98.276.10

J. Meyer Lebolt established the retail jewelry firm of Lebolt and Company in Chicago in 1899. In 1912 he added a silver shop to meet the demand for handwrought silverware, offering clients moderately priced handmade goods in popular styles. Lebolt may have modeled his shop on the Marshall Field and Company Craft Shop just down the street. The Lebolt shop at first offered tea and coffee services and flatware in simple Arts and Crafts styles with hammered surfaces. After the First World War, the firm expanded its line to include traditional Gothic and Georgian styles as well. The metal shop closed during the Second World War as a result of metal rationing, but the jewelry company is still in business.

Composed of a simple glass tube with a hand-beaten silver base and curved silver handle, this Lebolt bud vase is a classic example of form following function. The design is similar to copper and glass bud vases produced in the Arts and Crafts tradition by the Roycroft Shops in East Aurora, New York.

RELEVANT TEXTS

Darling, *Chicago Metalsmiths*, pp. 74, 94, 105–11.

Duncan, *Modernism*, p. 49, 58.

Volpe and Cathers, *Treasures of the American Arts and Crafts Movement*, pp. 18, 150.

EXHIBITIONS

Modernist Metalwork, 1900–1940, Norwest Center, Minneapolis, 1996–97

Milestones of Modernism, 1880–1940: Selections from the Norwest Collection,
 The Minneapolis Institute of Arts, 1999

PROVENANCE

Historical Design, Inc., New York (dealer)

Norwest Corporation, Minneapolis

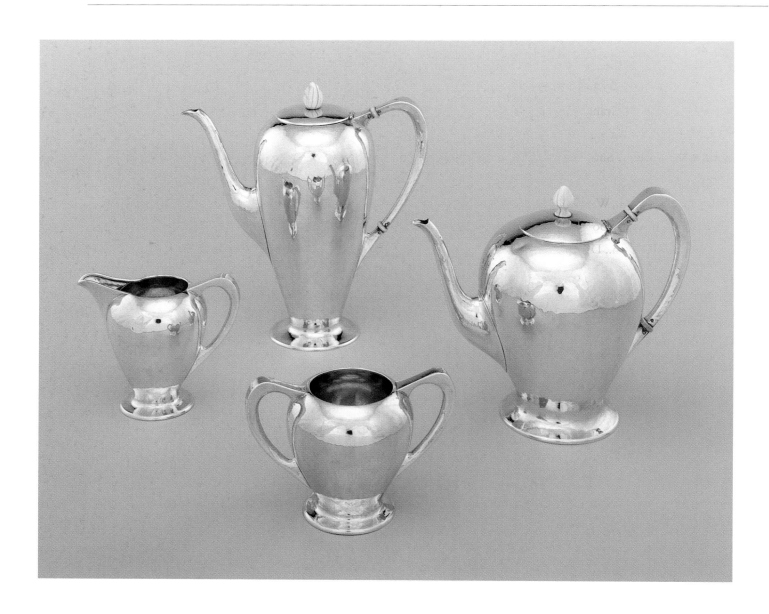

46.

COFFEE AND TEA SERVICE about 1914

DESIGNERS: Grant Wood (American, 1892–1942) and Kristopher Haga (American, active about 1905–about 1920)

MAKER: Volund Shop, Park Ridge, Illinois, 1914–16

Silver and ivory

Coffeepot: H 9⅝ in., W 9¼ in., Diam 4⁹⁄₁₆ in.; teapot: H 7¹¹⁄₁₆ in., W 9½ in., Diam 5½ in.; sugar bowl: H 4¹⁄₁₆ in., W 6³⁄₁₆ in., Diam 3¹³⁄₁₆ in.; creamer: H 4½ in., W 5½ in., Diam 3⁵⁄₁₆ in.

Marks: Two S's crossed within a circle (all pieces); "Handwrought/Sterling" and "485" (coffeepot, sugar bowl); "Volund/Hand Made/Sterling" (teapot); "Handwrought/Sterling" (creamer)

Gift of Sandra and Peter Butler 97.143.1.1–4

VOLUND SHOP MARK ON TEAPOT

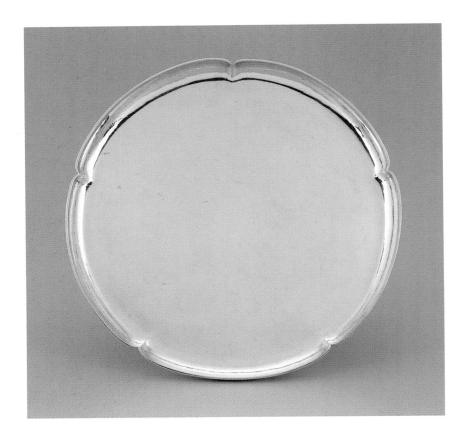

47.

HORS D'OEUVRES TRAY about 1914

DESIGNERS: Grant Wood (American, 1892–1942) and Kristopher Haga (American, active about 1905–about 1920)

MAKER: Volund Shop, Park Ridge, Illinois, 1914–16

Silver

H $^{13}/_{16}$ in., Diam 12$^{1}/_{8}$ in.

Marks: "Volund/Handwrought/Sterling"

Gift of Sandra and Peter Butler

97.143.2

In 1913 the young artist Grant Wood was a night student at the School of the Art Institute of Chicago. During the day he worked at the Kalo Shop (see nos. 39 and 40), earning sixteen dollars a week. There he met Kristopher Haga, a Norwegian silversmith, and in June 1914 the two of them opened the Volund Shop, named for the smith of Norse legend. For the most part, Wood and Haga produced modest silver items and gold jewelry, but along more ambitious lines they also made some hollowware like the rare coffee and tea service (no. 46) and this hors d'oeuvres tray. They closed the shop after only eighteen months, probably for lack of funds. Wood went on to become a celebrated painter, best known for his *American Gothic* (1930). Haga returned to the Kalo Shop, where he worked until about 1920.

The gently rounded forms and graceful spouts and handles of the coffee and tea service bring to mind the rolling curves and swelling treetops of Wood's *Birthplace of Herbert Hoover, West Branch, Iowa* (1931), a painting now owned jointly by The Minneapolis Institute of Arts and the Des Moines Art Center. The hors d'oeuvres tray demonstrates special skill and craftsmanship, as silver trays tend to weaken on the diagonal during shaping.

RELEVANT TEXTS

Darling, *Chicago Metalsmiths*, p. 63.

EXHIBITIONS

Masters of American Metalsmithing, National Ornamental Metal Museum,

Memphis, Tennessee, 1988

PROVENANCE

Dan J. and Lila Madtson

William Core Duffy, Kittery, Maine (dealer)

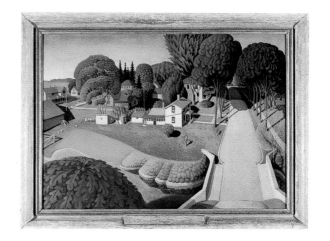

GRANT WOOD'S *BIRTHPLACE OF HERBERT HOOVER, WEST BRANCH, IOWA*, 1931 (THE JOHN R. VAN DERLIP FUND, MRS. HOWARD H. FRANK, AND THE EDMUNDSON ART FOUNDATION, INC.)

APPENDIX

Selected Prairie School Buildings in the Twin Cities Area

This list includes only buildings by William Purcell, George Feick, George Elmslie, Frank Lloyd Wright, and George Maher. Please note that most are private residences.

PURCELL AND FEICK (1907–9)

Catherine Gray House, 1907
2409 East Lake of the Isles Boulevard, Minneapolis

H. J. Meyers House, 1908
2513 Garfield Avenue South, Minneapolis

Henry G. Goosman House, 1909
2532 Pillsbury Avenue South, Minneapolis

Mrs. Terrance W. McCosker House, 1909
4615 Lake Harriet Boulevard, Minneapolis

H. P. Gallaher House, 1909–10
Minnetrista

Stewart Memorial Presbyterian Church,
1909–10
Now Redeemer Missionary Baptist Church
116 East 32nd Street, Minneapolis

PURCELL, FEICK AND ELMSLIE
(1910–13)

W. E. Baker House, 1910
1805 Fremont Avenue South, Minneapolis

Edward Goetzenberger House, 1910
2621 Emerson Avenue South, Minneapolis

Harold E. Hineline House, 1910
4920 Dupont Avenue South, Minneapolis

E. L. Powers House, 1910
1635 West 26th Street, Minneapolis

Paul Mueller Studio, 1910–11
4835 Bryant Avenue South, Minneapolis

Lyman E. Wakefield House, 1911
4700 Fremont Avenue South, Minneapolis

Dr. Oscar Owre House, 1911–12
2625 Newton Avenue South, Minneapolis

Ward Beebe House, 1912
Also known as the John Leuthold House
2022 Summit Avenue, St. Paul

E. C. Tillotson House, 1912
2316 Oliver Avenue South, Minneapolis

Charles Parker House, 1912–13
4829 Colfax Avenue South, Minneapolis

Maurice I. Wolf House, 1912–13
Built about 1918
4109 Dupont Avenue South, Minneapolis

OPPOSITE
STEWART MEMORIAL
PRESBYTERIAN
CHURCH, 1909–10,
PURCELL AND FEICK

C. T. BACHUS
HOUSE, 1915,
PURCELL AND
ELMSLIE

C. T. Bachus House, 1915
212 West 36th Street, Minneapolis

Fritz Carlson House, 1916–17
3612 17th Avenue South, Minneapolis

Charles Wiethoff House, 1917
4609 Humboldt Avenue South, Minneapolis

PURCELL AND ELMSLIE (1913–21)

Edward W. Decker House, 1912–13
Razed 1948; garage still standing
Wayzata

Edna S. Purcell House, 1913
Now the Purcell-Cutts House
2328 Lake Place, Minneapolis

Open Air Theater for Thaddeus P. Giddings,
1914
Ferry Street, Anoka

WILLIAM GRAY PURCELL (1921–41)

Peterson House, 1927–28
3 Red Cedar Lane, Minneapolis

WITH FREDERICK STRAUEL:

House, 1928
5315 Upton Avenue South, Minneapolis

House, 1928
5319 Upton Avenue South, Minneapolis

House, 1928
5312 Vincent Avenue South, Minneapolis

House, 1928
5217 Vincent Avenue South, Minneapolis

House, 1929
5312 Upton Avenue South, Minneapolis

House, 1932
5309 Upton Avenue South, Minneapolis

Carson House, 1941
6001 Pine Grove Road, Edina

Malcolm Willey House, 1934
255 Bedford Street Southeast, Minneapolis

Henry J. Niels House, 1950–51
2801 Burnham Boulevard, Minneapolis

Paul Olfelt House, 1958–59
2206 Parklands Lane, St. Louis Park

GEORGE WASHINGTON MAHER
(1888–1922)

Charles J. Winton, Sr., House, 1910
1324 Mount Curve Avenue, Minneapolis

FRANK LLOYD WRIGHT (1893–1959)

Francis W. Little House, 1912–14
Razed 1972; service building still standing
Deephaven

BIBLIOGRAPHY

Abernathy, Ann. *The Oak Park Home and Studio of Frank Lloyd Wright*. Chicago: The Frank Lloyd Wright Home and Studio Foundation, 1998.

Adler, Dankmar. "The Theater." Edited by Rachel Baron. *Prairie School Review* 2, no. 2 (1965): 21–27.

Bahnemann, Greta. "George Maher's Rockledge: A Study in Architecture, Patronage, and Consumption." M.A. thesis, University of Delaware, Winterthur Program in Early American Culture, 1994.

Barter, Judith A. "The Prairie School and Decorative Arts at the Art Institute of Chicago." In *The Prairie School: Design Vision for the Midwest*, pp. 113–33. The Art Institute of Chicago Museum Studies, vol. 21, no. 2. 1995.

Barter, Judith A., et al. *American Arts at the Art Institute of Chicago: From Colonial Times to World War I*. Chicago: Art Institute of Chicago, 1998.

Bock, Richard. *Memoirs of an American Artist: Richard W. Bock*. Los Angeles: C. C. Publishing Company, 1989.

Bowman, Leslie Greene. *American Arts and Crafts: Virtue in Design*. Boston: Los Angeles County Museum of Art in association with Bulfinch Press/Little, Brown and Company, 1990.

Brooks, H. Allen. *Frank Lloyd Wright and the Prairie School*. New York: George Braziller, published in association with the Cooper-Hewitt Museum, 1984.

———. *The Prairie School: Frank Lloyd Wright and His Midwest Contemporaries*. 1972. Reprint, New York: W. W. Norton and Company, 1996.

Clark, Robert Judson, ed. *The Arts and Crafts Movement in America, 1876–1916*. 1972. Reprint, in a new format with an updated bibliography and a new preface by the editor, Princeton, New Jersey: Distributed by Princeton University Press, 1992.

Conforti, Michael, ed. *Minnesota 1900: Art and Life on the Upper Mississippi, 1890–1915*. Newark: University of

Delaware Press; London and Toronto: Associated University Presses in association with The Minneapolis Institute of Arts, 1994.

The Craftsman Table. New York: Hirschl and Adler Galleries, 1992.

Darling, Sharon S. *Chicago Ceramics and Glass: An Illustrated History from 1871 to 1933*. Chicago: Chicago Historical Society, 1979.

———. *Chicago Furniture: Art, Craft, and Industry, 1833–1983*. New York: Chicago Historical Society in association with W. W. Norton and Company, 1984.

———. *Chicago Metalsmiths: An Illustrated History*. Chicago: Chicago Historical Society, 1977.

———. *Teco: Art Pottery of the Prairie School*. Erie, Pennsylvania: Erie Art Museum, 1989.

de Wit, Wim, ed. *Louis Sullivan: The Function of Ornament*. New York: W. W. Norton and Company, 1986.

Duncan, Alastair. *Modernism: Modernist Design, 1880–1940; the Norwest Collection, Norwest Corporation, Minneapolis*. Woodbridge, Suffolk: Antique Collectors' Club, 1998.

Frank Lloyd Wright Retrospective Exhibition. New York: Hirschl and Adler Galleries, 1989.

From Architecture to Object: Masterworks of the American Arts and Crafts Movement. New York: Hirschl and Adler Galleries, 1989.

Futagawa, Yukio, ed. *Frank Lloyd Wright Monograph*. 12 vols. Text by Bruce Brooks Pfeiffer. Tokyo: A.D.A. Edita, 1987.

Gebhard, David. "A Guide to the Architecture of Purcell and Elmslie." *Prairie School Review* 2, no. 1 (1965): 16–24.

———. "Purcell and Elmslie, Architects." *Prairie School Review* 2, no. 1 (1965): 5–15.

———. "William Gray Purcell and George Grant Elmslie and the Early Progressive Movement in American Architecture from 1900 to 1920." Ph.D. dissertation, University of Minnesota, Minneapolis, 1957.

Gebhard, David, and Tom Martinson. *A Guide to the Architecture of Minnesota*. Minneapolis: Published by the University of Minnesota Press for the University Gallery of the University of Minnesota and the Minnesota Society of Architects, 1977.

Hanks, David A. *The Decorative Designs of Frank Lloyd Wright*. New York: E. P. Dutton, 1979.

———. *Frank Lloyd Wright: Preserving an Architectural Heritage; Decorative Designs from the Domino's Pizza Collection*. New York: E. P. Dutton, 1989.

Heckscher, Morrison. "Collecting Period Rooms: Frank Lloyd Wright's Francis Little House." In *The Chase, the Capture: Collecting at the Metropolitan*, pp. 207–17. New York: Metropolitan Museum of Art, 1975.

Heckscher, Morrison, and Elizabeth G. Miller. *An Architect and His Client: Frank Lloyd Wright and Francis W. Little*. New York: Metropolitan Museum of Art, 1973.

Hollander, Gary. "Rockledge: A Summer House Designed by George W. Maher." *Tiller* 1, no. 6 (July/August 1983): 9–16.

In Pursuit of Order: Frank Lloyd Wright from 1897 to 1915. Chicago: Struve Gallery, 1988.

James, Cary. *The Imperial Hotel: Frank Lloyd Wright and the Architecture of Unity*. Rutland, Vermont: Charles E. Tuttle Company, 1968. Reprinted as *Frank Lloyd Wright's Imperial Hotel*, New York: Dover Publications, 1988.

Jordy, William H. "The 'Little House' at the Metropolitan." *The New Criterion*, January 1983, pp. 56–61.

Kaplan, Wendy. *"The Art That Is Life": The Arts and Crafts Movement in America, 1875–1920*. 1987. Reprint, Boston: Little, Brown and Company, Bullfinch Press, 1998.

Kardon, Janet, ed. *The Ideal Home, 1900–1920: The History of Twentieth-Century American Craft*. New York: Harry N. Abrams in association with the American Craft Museum, 1993.

Kaufmann, Edgar, Jr. *Frank Lloyd Wright at the Metropolitan Museum of Art*. New York: Metropolitan Museum of Art, 1982.

Kruty, Paul Samuel. *Frank Lloyd Wright and Midway Gardens*. Urbana: University of Illinois Press, 1998.

Lanegran, David A., and Ernest R. Sandeen. *The Lake District of Minneapolis: A History of the Calhoun-Isles Community*. St. Paul, Minnesota: Living Historical Museum, 1979.

Legler, Dixie. *Prairie Style: Houses and Gardens by Frank Lloyd Wright and the Prairie School*. New York: Stewart, Tabori and Chang, 1999.

Maher, George. "An Architecture of Ideas." Reprinted in *Tiller* 2, no. 4 (March/April 1984): 45–48.

Millett, Larry. *The Curve of the Arch: The Story of Louis Sullivan's Owatonna Bank*. St. Paul: Minnesota Historical Society Press, 1985.

Mollman, Sarah C., ed. *Louis Sullivan in the Art Institute of Chicago: The Illustrated Catalogue of Collections*. New York: Garland Publishing, 1989.

Montgomery, Susan J. *The Ceramics of William H. Grueby: The Spirit of the New Idea in Artistic Handicraft*. Lambertville, New Jersey: Arts and Crafts Quarterly Press, 1993.

Morrison, Hugh. *Louis Sullivan, Prophet of Modern Architecture*. 1935. Reprint, with an introduction and revised list of buildings by Timothy J. Samuelson, New York: W. W. Norton and Company, 1998.

O'Gorman, James F. *Three American Architects: Richardson, Sullivan, and Wright, 1865–1915*. Chicago: University of Chicago Press, 1991.

Phillips, Lisa, et al. *High Styles: Twentieth-Century American Design*. New York: Whitney Museum of American Art in association with Summit Books, 1985.

Prairie School Architecture in Minnesota, Iowa, Wisconsin. St. Paul: Minnesota Museum of Art, 1982.

Purcell, William Gray. *St. Croix Trail Country: Recollections of Wisconsin*. Minneapolis: University of Minnesota Press, 1967.

Purcell, William Gray. Papers. Northwest Architectural Archives, University of Minnesota Libraries, Minneapolis.

Riley, Terence, ed. *Frank Lloyd Wright, Architect*. New York: Museum of Modern Art, 1994.

Robertson, Cheryl. *Frank Lloyd Wright and George Mann Niedecken: Prairie School Collaborators*. Milwaukee: Milwaukee Art Museum; Lexington, Massachusetts: Museum of Our National Heritage, 1999.

Saliga, Pauline, ed. *Fragments of Chicago's Past: The Collection of Architectural Fragments at the Art Institute of Chicago*. Chicago: Art Institute of Chicago, 1990.

Sanderson, Arlene, ed. *Wright Sites: A Guide to Frank Lloyd Wright Public Places*. Revised 2nd ed. New York: Princeton Architectural Press, 1995.

Spencer, Brian A., ed. *The Prairie School Tradition: The Prairie Archives of the Milwaukee Art Center*. New York: Whitney Library of Design, 1979.

Sprague, Paul E. "Adler and Sullivan's Schiller Building." *Prairie School Review* 2, no. 2 (1965): 5–20.

———. "Sullivan's Scoville Building, a Chronology." *Prairie School Review* 2, no. 3 (1974): 16–23.

Storrer, William Allin. *The Architecture of Frank Lloyd Wright: A Complete Catalog*. 2nd ed. 1978. Reprint, Cambridge: MIT Press, 1982.

Sullivan, Louis H. *The Autobiography of an Idea*. 1924. Reprint, with a new introduction by Ralph Marlowe Line, New York: Dover Publications, 1956.

———. *Kindergarten Chats and Other Writings*. 1947. Reprint, New York: Dover Publications, 1979.

Twombly, Robert. *Louis Sullivan: His Life and Work*. Chicago: University of Chicago Press, 1986.

Victoria and Albert Museum. *Art and Design in Europe and America: 1800–1900*. New York: E. P. Dutton, 1987.

Vinci, John. *The Trading Room: Louis Sullivan and the Chicago Stock Exchange*. Chicago: Art Institute of Chicago, 1989.

Volpe, Tod M., and Beth Cathers. *Treasures of the American Arts and Crafts Movement, 1890–1920*. New York: Harry N. Abrams, 1988.

Weingarden, Lauren S. "Naturalized Nationalism." *Winterthur Portfolio* 24, no. 1 (Spring 1989): 41–68.

The Work of Purcell and Elmslie, Architects. With a new introduction by David Gebhard. Park Forest, Illinois: Prairie School Press, 1965.

Wright, Frank Lloyd. *An Autobiography*. New York: Duell, Sloan and Pearce, 1943.

Wright, Frank Lloyd. *Frank Lloyd Wright on Architecture: Selected Writings, 1894–1940*. Edited by Frederick Gutheim. New York: Duell, Sloan and Pearce, 1941.

Major sources of information on Purcell and Elmslie's work are H. Allen Brooks's *The Prairie School: Frank Lloyd Wright and His Midwest Contemporaries*; David S. Gebhard's dissertation "William Gray Purcell and George Grant Elmslie and the Early Progressive Movement in American Architecture from 1900 to 1920"; Mark Hammons's "Purcell and Elmslie, Architects," in *Minnesota 1900: Art and Life on the Upper Mississippi, 1890–1915* (ed. Conforti); and the William Gray Purcell Papers in the Northwest Architectural Archives, which include para-biographies, job files, and working drawings.

ACKNOWLEDGMENTS

This publication would not have been possible without the tireless work of Corine Wegener, who participated enthusiastically and on short notice in the intense period of research, writing, and organization. Thanks also go to my colleagues, past and present, for providing material that made its way into this book: Catherine Futter, Trent Nichols, and David Ryan. Thanks to Wendy Kaplan for setting a good example and for helpful suggestions at a critical point in the project's development. Special thanks go to Christopher Monkhouse for championing this needed publication, for his assistance in planning it, and for his improvements to the text. For providing information on their respective family's commissions, I would like to thank Judy Dayton, Jean Haverstock, and Vidar Ishmael.

For furthering my understanding of the Purcell-Cutts house and the work of Purcell and Elmslie, special thanks to Barb Bezat and Alan Lathrop, of the Northwest Architectural Archives, University of Minnesota Libraries, Minneapolis, particularly to Barb for her assistance during our research crunch in preparing this publication. The following people also generously contributed to my research on and knowledge of Purcell and Elmslie: Jennifer Downs at the Art Institute of Chicago, Beth Dennis Dunn, Patricia Gebhard, Mark Hammons, Krista Finstad Hanson, Ann Kohls, Brian Kraft, Richard Kronick, Stuart MacDonald and Bob Mack, Georgia Pavoloni, Tran Turner, and Alex Wilson. Thanks especially to Michael Conforti, for establishing my official link to the Purcell-Cutts house in 1994 by naming me house curator, to carry on the museum's stewardship of the house, an endeavor he began ten years before in conversations with Anson Cutts, Jr. Thanks to all the caretakers of Purcell structures who have opened their doors to me over the years, including Peter and Nancy Albrecht, Alan and Jenna Amis, Rolf Anderson, Jean Chesley and her late husband Frank,

Clifton Johns, Randy Kurth and Dorset Penick, Ed and Maureen Labenski, and Richard Mann.

A generous thanks to our editor, Elisabeth Sövik, for her skillful work in forming the material into a cohesive whole. Thanks to Deb Miner, who took the myriad elements of this book and created a lively and attractive design in the spirit of progressivism. Gary Mortensen, Bob Fogt, Todd Strand, and Alec Soth all went beyond the call of duty to produce photographs of collection objects, often on a tight schedule. The Art Institute of Chicago, the Frank Lloyd Wright Archives, Susan Gilmore, the Kenilworth Historical Society, Christian Korab, Karen Melvin, the Minnesota Historical Society, the Richard Nickel Committee, the Northwest Architectural Archives, David R. Phillips of the Chicago Architectural Photographing Company, and the State Historical Society of Wisconsin all provided images for this book on short notice. Nicole Gibbs, our administrative assistant, provided support in too many ways to count. Thanks to John Easley and Joan Olson of the museum's Development Department for their efforts in making the wish for this publication a reality. Don Leurquin professionally shepherded the book to completion. I would like to thank my husband, Enrique Olivarez, Jr., for reading my drafts and offering many very good suggestions. I also thank my parents, Mike and Nancy Komar, for their constant encouragement. And finally, I would like to single out for thanks all of the volunteers, especially docents and greeters, who have been involved with the Purcell-Cutts house over the last ten years. Their role as enthusiastic ambassadors of the house is very much appreciated.

JENNIFER KOMAR OLIVAREZ

ASSISTANT CURATOR

DEPARTMENT OF DECORATIVE ARTS, SCULPTURE,

AND ARCHITECTURE

INDEX

Page numbers in *italics* refer to illustrations.

Purcell, Cecily O'Brien, 71n57

Purcell, Charles A., 22, *27,* 57

Purcell, Douglas, *6, 18, 51;* adopted, 58, 69n24; death, 63

Purcell, Edna Summy, *6, 27, 28, 29, 33, 34, 44, 50, 51;* marriage, 28; family, 32–33; plans house, 40, 41, 50; embroidery, 52; divorce, 63

Purcell, James, *6, 18, 33, 34, 51;* adopted, 32

Purcell, William Gray, *18,* 21, *23, 28, 29, 51, 63;* career, 12–15, 24, 63; childhood, 22–23; education, 23–24; designs houses, 26–28, 31, 68n4, 71n56, 81, 124–27, *125, 127,* 176–79; marriage, 28; designs furniture, 28, 29, 58, 108–11, *108–11,* 115–19, *115–19,* 124–27, *124, 127;* divorce, 63; death, 63; honored, 65; plans for future of Edna S. Purcell house, 65–66; window designs, 112–13, *112–13,* 122–23, *122–23;* watercolor, *113;* bank designs, 115, 122–23, *122–23,* 130–31, *130–31;* designs light fixtures, 120, *120,* 128–29, *128*

Purcell and Elmslie, architects, 26, 63, 69n15, 70n35, 116, 120, 121, 124, 125, 128, 130, 178. *See also personal names*

Purcell and Feick, architects, 24, 26, 109, 176–77. *See also personal names*

Purcell-Cutts house (Edna S. Purcell house), 116, 178; façade, *2–3, 17,* 19, *36, 37, 38, 39, 62;* fireplace, *4–5, 47, 48,* 49; built, 18, 32–33; furniture, 28, *29,* 50, 52–53, *53,* 57, 58, 59, *59;* garden, *33, 34,* 36, *36;* site, 35; plan, *35, 40,* 41; exterior described, 38–39; decorative elements, *38, 39;* open plan, 41, 52–53; entry, *42,* 43, *43;* windows, 43, *43, 44,* 45–46, *45–46,* 50, 52–53, 57, *57,* 58, 60; living room, 43–53, *44, 46, 47, 48, 50, 51;* interior decoration, 45, *45;* light fixtures, 53, *53,* 55, 56, 57, *57,* 120, *120;* dining room, 54–55, *54, 55;* porches, 56, *56,* 59; second floor, 57–59, *57, 58, 59;* maid's room, 60; kitchen, 60–62, *61;* phone room, 62; basement, 62–63; sold, 64; donated to Minneapolis Institute of Arts and restored, 65–67; model, 121, *121*

Purcell, Feick and Elmslie, architects, *25,* 26, 30, 69n15, 109, 114, 115, 122, 123, 177. *See also personal names*

PHOTO CREDITS

EDITOR Elisabeth Sövik

STAFF PHOTOGRAPHERS Gary Mortensen, Robert
Fogt, Todd Strand, Alec Soth

PRODUCTION COORDINATOR Donald Leurquin

DESIGNER Deb Miner

© 2000 by The Minneapolis Institute of Arts
2400 Third Avenue South
Minneapolis, Minnesota 55404
All rights reserved

Printed in Belgium

Distributed by the University of
 Minnesota Press
111 Third Avenue South, Suite 290
Minneapolis, Minnesota 55401-2520
www.upress.umn.edu

Library of Congress Catalog Card Number
 00-133289
ISBN 0-8166-3847-0

FRONT COVER The Edna S. Purcell house
(now the Purcell-Cutts house) in winter,
about 1914

FRONT FLAP Detail of fireplace brick from the
Purcell-Cutts house

BACK COVER Clockwise from upper left,
catalogue nos. 10, 37, 33, 17, 46, 8;
center, no. 28

BACK FLAP James and Douglas Purcell looking
at books in the Edna S. Purcell house,
probably late 1916

INSIDE COVERS AND FACING PAGES Detail of
elevator grille (no. 3)

PAGES 2-3 The Purcell-Cutts house

PAGES 4-5 Fireplace mural by Charles Livingston
Bull at the Purcell-Cutts house

PAGES 6-7 Edna, Douglas, and James Purcell
on the prow at the Edna S. Purcell house,
probably late 1916

PAGE 11 View from entry, Purcell-Cutts house